FASHION DRAWING

BASIC PRINCIPLES

FASHION DRAWING

BASIC PRINCIPLES

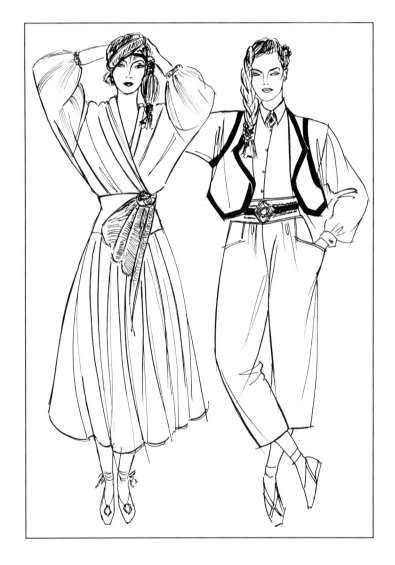

Anne Allen and Julian Seaman

B.T. Batsford Ltd · London

© Anne Allen and Julian Seaman

First published 1993
Reprinted 1993, 1994, 1995, 1996

Typeset by Servis Filmsetting Ltd, Manchester
and printed in Great Britain by
Butler & Tanner Ltd, Frome and London
for the publishers
B.T. Batsford Ltd
4 Fitzhardinge Street
London W1H 0AH

ISBN 0 7134 7096 8

A CIP catalogue record for this book is available from the
British Library

CONTENTS

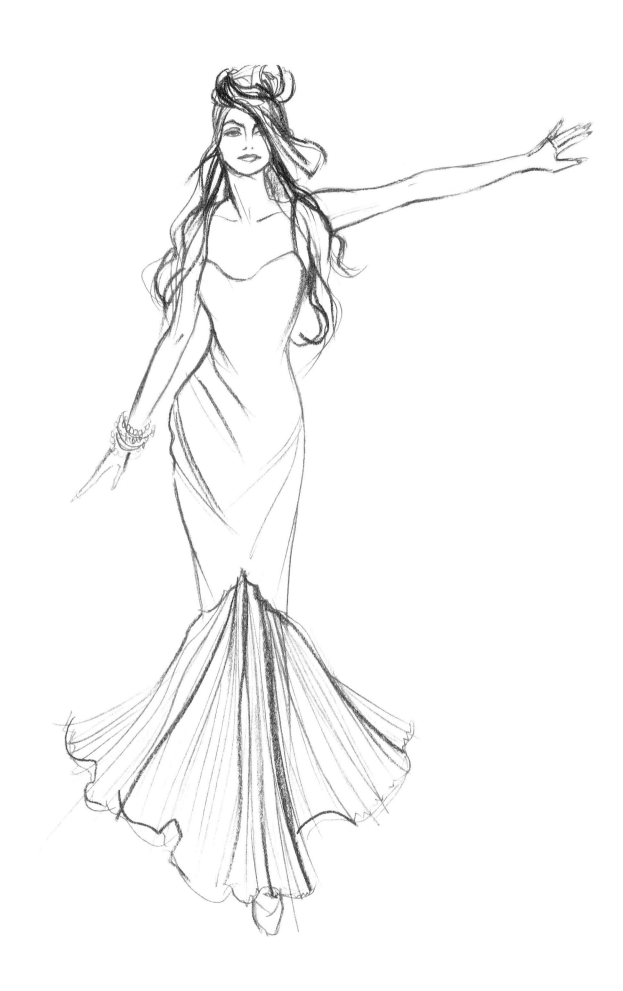

It is possible to become one of the best fashion illustrators, without ever having had one original design idea. It is equally possible to become a top fashion designer without having any ability to draw. The two unique skills do, however, usually overlap in an industry which is geared to visual appeal.

At student level both disciplines tend to be taught concurrently. It is an advantage for the budding illustrator to have 'fashion sense', and for a designer to be able to put ideas on to paper.

The resultant drawings serve two very different purposes. The professional illustrator's work is used to promote a completed design in the same way that a photographer's would. A design drawing, however, will be used in a design studio to bring the concept from drawing board to catwalk. Nevertheless, the overlap of approach is demonstrable, since the same piece of artwork *could* serve both purposes.

Fashions and styles are always changing. Everyone's artistic 'handwriting' is different, but the basic shape and proportions of the human body remain constant.

Much can be learnt from that tested and proven institution, the Life Class, where the student embarks on a self-critical voyage of discovery. But it can be equally helpful to have a permanent reference to go back to.

This book starts with the basics, explaining the glamorizing elongation of proportions and showing how to draw the body from different angles (including the often neglected back view). Included are many different poses, which have been deliberately reproduced in A4 size so that they can be traced onto layout paper, to assist in the completion of a drawing. The book also explores the use of photographic sources in developing the composition of an illustration.

Also included are tips on drawing limbs like hands and feet, which require careful attention. There are many illustrations in basic terms, showing how various garment shapes and details can be drawn, without falling into the trap of showing instantly outdated fashion.

Fashion Drawing: The Basic Principles can be used as a reference and is designed to build up confidence, but it is *not* an excuse to neglect observations from life. Confidence will result in a drawing, whether an illustration or a design idea, that is bold and positive. The inspiration must be yours, but this book can help you present it to the best advantage.

BASIC ANATOMY

THE SKELETON

Any book on figure drawing should start with the basics, and the skeleton is the framework on which all creative ideas must hang. There are, of course, *minor* differences in the basic shape between the sexes, which will also be explained. But the proportions of one part of the body to another can be considered as a constant when starting out, as shown on page 18.

The skeleton demonstrates why the body fills and reduces, bends and balances in a particular way. Through evolution our four-legged frame has distorted, but the main axle, the strength on which the rest of the body depends, remains the spine or backbone. It supports the skull from behind at roughly eye level and, being a stack of independent discs, has considerable mobility backwards, forwards and sideways.

The rib cage starts at shoulder level from the spine, and curves forward creating the cavity for vital organs. Though the ribs tilt down from the neck to the front, they raise up again to meet the centre of the chest.

The shoulder-blades and sockets also attach to the rear of the body, behind and outside the rib cage, as well as being connected to the top of the breast plate at the front, by the clavicles, or collar bones.

Below the rib cage, the spine continues until it meets the pelvis, before it carries on down to its base, where it used to extend to a tail.

The two scoops of the pelvic bones at the back, the top of which create the hips, hold in the other internal organs. The gap between the pelvis and rib cage produces the narrowing at the waist.

Since the spine supports the body from the rear, the forward points of a body are lower than the back points.

The top leg bone attaches its hip to the socket, almost turns a right angle, and comes inwards to the knee. It is only then that the lower leg bones go straight to the heel and the feet.

Like legs, the arms also start with one major bone, extending to the elbow at waist level, with two bones continuing to the wrist at hip level, before reaching the intricate hand structure.

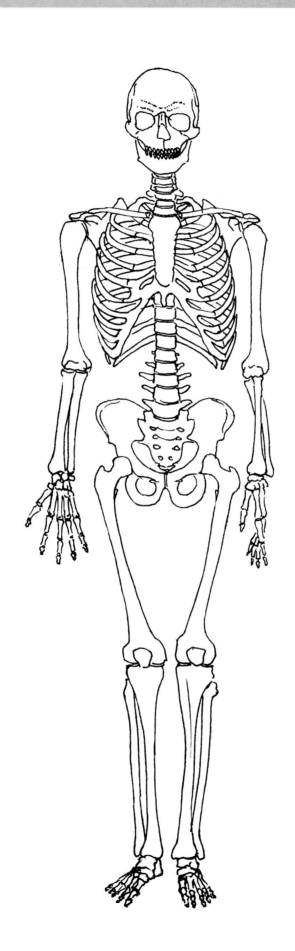

MUSCLES

Many life drawings, and most fashion illustrations, are depicted head on. This section shows this view point in its basic form, before exploring more ambitious poses.

Since this book is intended as a simple drawing aid, and not a medical reference, the technicalities have been kept to a minimum. However, having established the framework of the skeleton, an illustrator needs to know the shapes of the muscles and fat which hold both the bones and organs in place and create movement.

There is a separate section on heads, so the first muscle section to observe is the neck. The muscles at the front curve from just below each ear, come down more narrowly than the head-on corners of the jaw bone and meet at the top of the chest, between the two collar bones, in the dent known as the 'salt cellar'. Notice, however, how the back shoulder muscles rise up to about half way between the 'salt-cellar' and the chin.

The arms are supported by the pectoral muscles across the chest and by the shoulder muscles. These muscles dip down briefly, half-way between the neck and the point of the shoulder. The outside of the arm continues down in three curves to the wrist. The first to the level of the armpit, the second to the (higher) back of the elbow, and finally down the longer forearm to the wrist.

The inside arm goes in two curves, from the armpit, to a lower elbow point, to the beginning of the ball of the hand and the thumb.

As explained, the body tapers at the waist and then fills out round the hips. Although the legs start here, the leg shape to the ankle creates two curves on the outer profile; from the waist down to the middle part of the knee, and from there to the ankle.

The tops of the legs have the strongest muscles in the body, and the inverted angles of the bones which meet at the knees are surrounded by flesh. This means that there is almost a straight line from the crotch, to the ankles. Unlike the arms, however, there are three small curves on the inside leg; the first stopping above the knee, the next encompassing the knee joint and the last continuing to the ankle.

 Note 1: The outline of the breasts often dictates how a garment will hang. From under the armpits they will protrude slightly outside the frame of the rib cage, flattened on the underside. When covered in a garment this produces the effect of a flat line across the bottom of the breasts which casts a shadow.

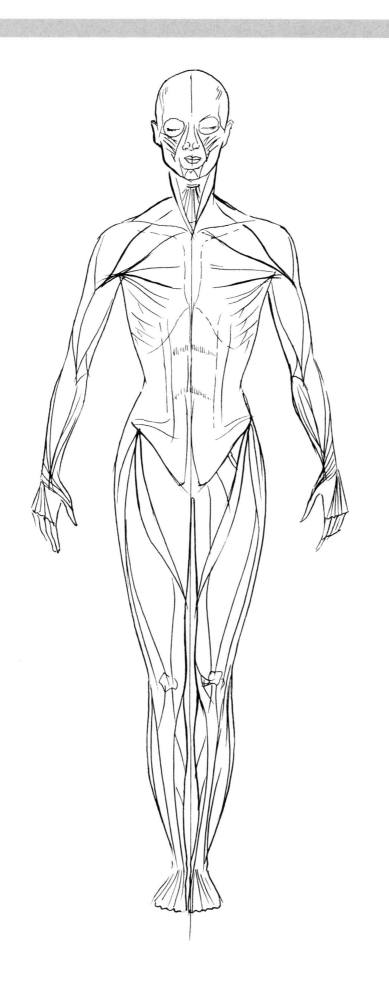

Illustrated is the fully fleshed-out body with the
fatty tissue added.

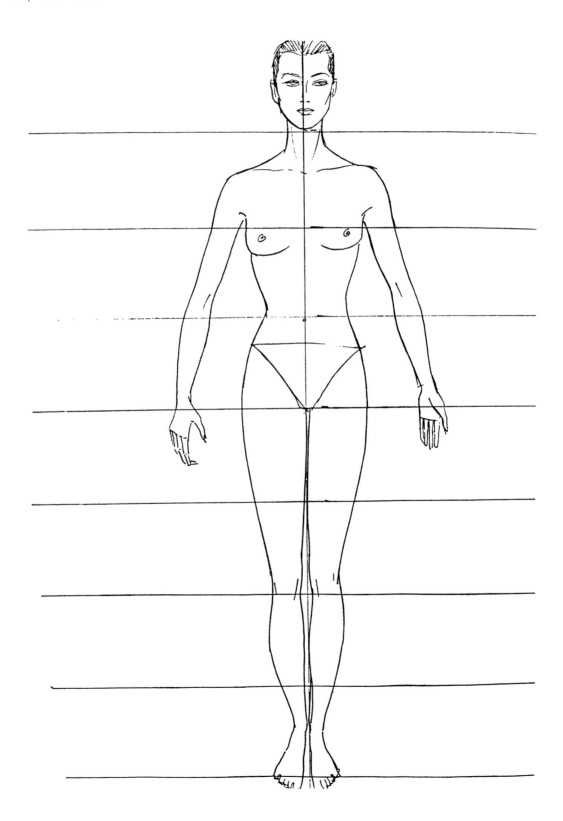

Here the back view shows how the spine holds
together the framework of the body.
Notice how high it enters the
back of the skull.

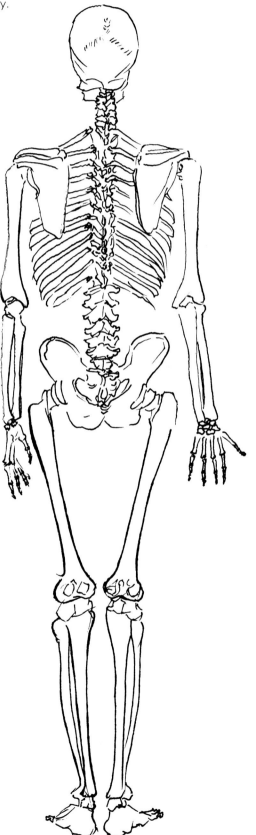

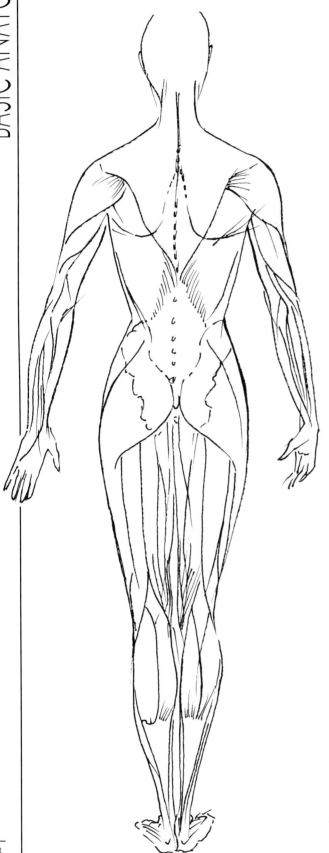

With the muscles included, the eventual body shape becomes apparent.

Once the fatty tissue and skin are added in, the main difference from the muscle drawing is the showing of the buttocks.

This book is designed to give helpful tips and can be used as a reference. But one thing which students often fail to realize is that when they draw a back view from a tracing of a front view, much of the back *elevation* is higher (this will be noticed in the side views) and the feet, conforming to perspective, go upwards from the ankle, not down. A back view drawing, in bare feet, will be shorter than a front view, from head to heel or head to toe.

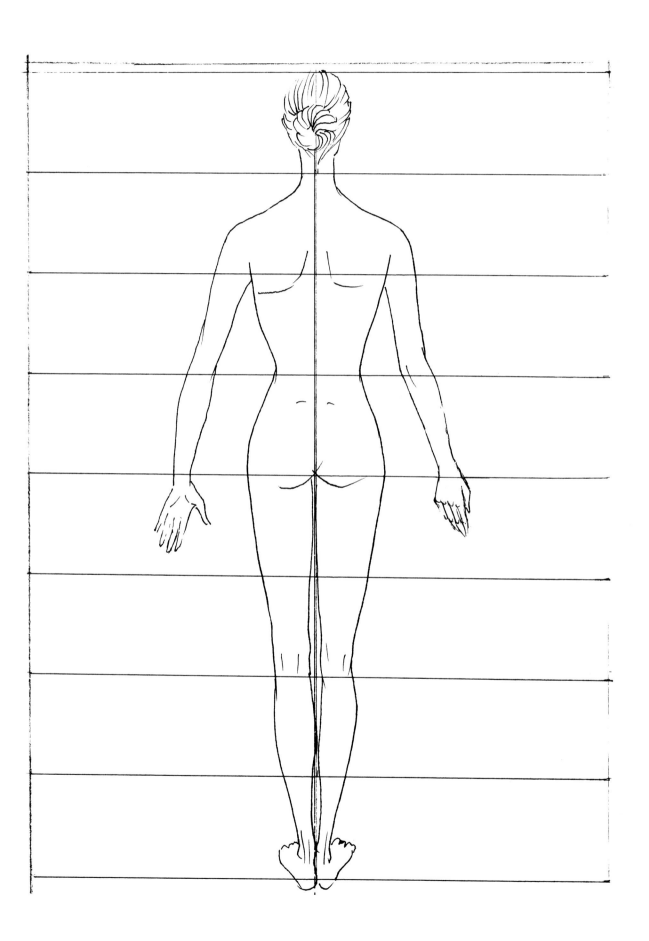

The side skeleton illustrates several things. First, the S bend of the spine, secondly the depth of the rib cage, and finally the forward and downward shope of the upper half of the body.

The muscle covering shows how the figure from the back comes down in six different curves from the top of the head: top of head to back of neck; back of neck to the small of the back; the buttocks;

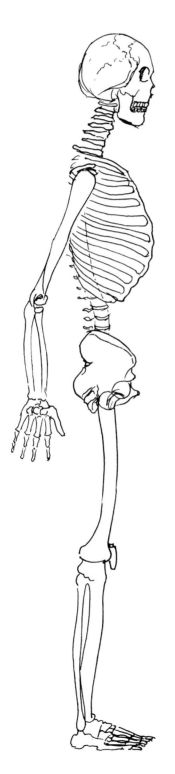

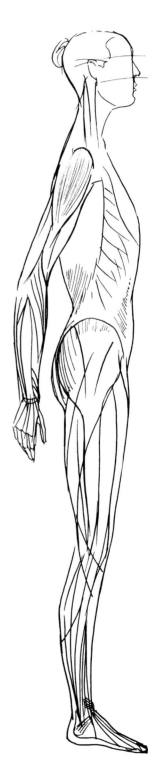

the thighs to the back of the knee; the calves to the ankle; the heel.

With the fat and flesh covering the body, the breasts sit on the chest. There is a slight bulge at the stomach and the buttocks become more rounded.

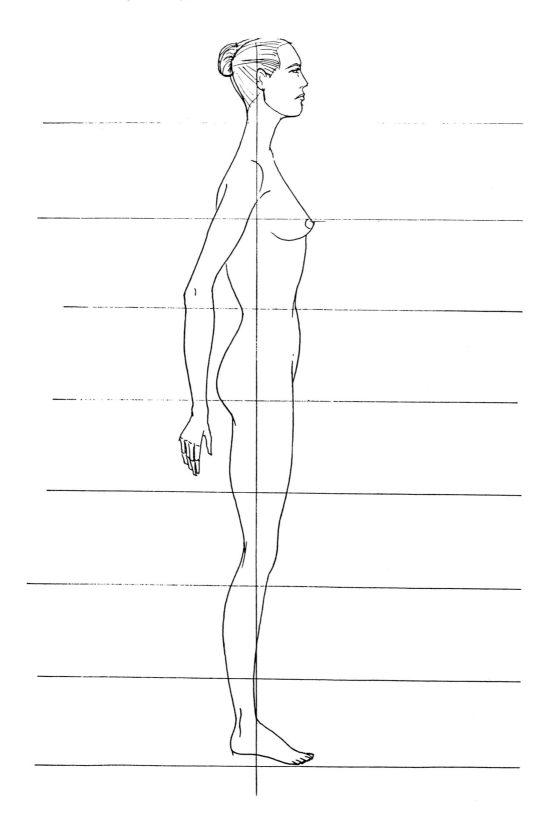

PROPORTION

Figures should be drawn in proportion. A popular aid is to measure the body in multiples of the head length.

In nature, one head equals $7\frac{1}{2}$ body lengths to the ankles (the feet from the front view protrude to make this almost 8 to 1).

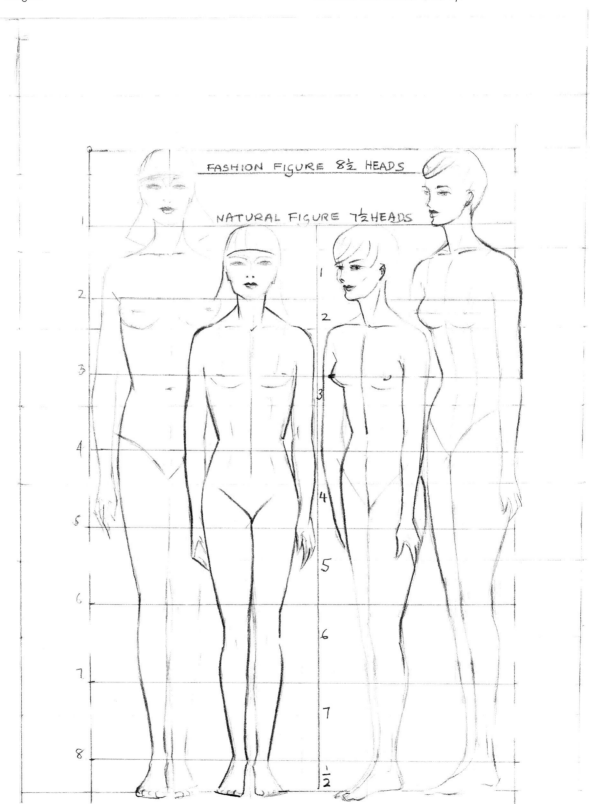

FASHION FIGURE $8\frac{1}{2}$ HEADS

NATURAL FIGURE $7\frac{1}{2}$ HEADS

For glamour purposes the figure is elongated.
From the head to the hips the proportions remain
exactly the same as in the natural figure, but the
legs are stretched. The ratio becomes $8\frac{1}{2}$ to 1.

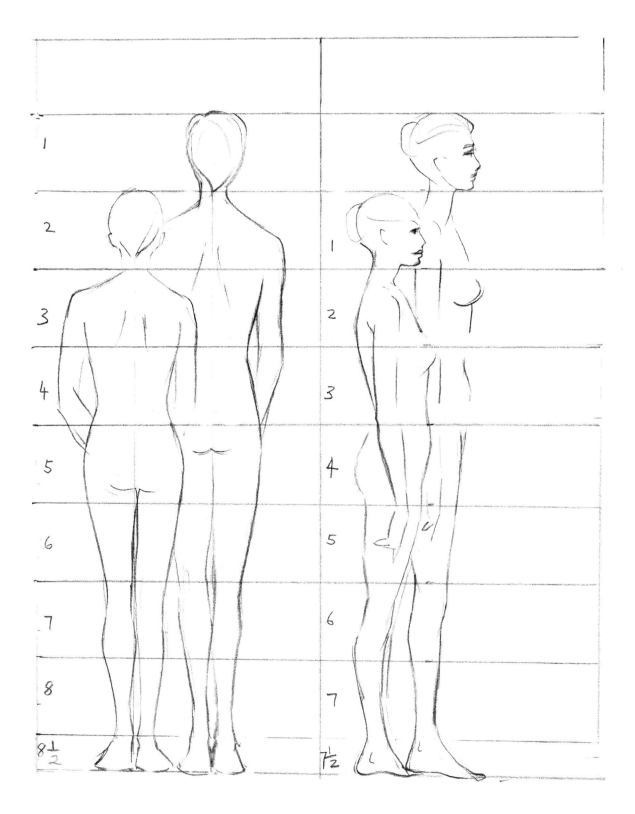

CHILDREN AND ADOLESCENTS

The proportions of the growing body differ from those of the fully-grown adult. Again, using the formula of measuring the whole body by relation to head size, infants are 4 heads, small children 5 (to the age of about six), seven to eleven year-olds are 7 heads, and, with slight leg elongation, adolescents measure 8 heads.

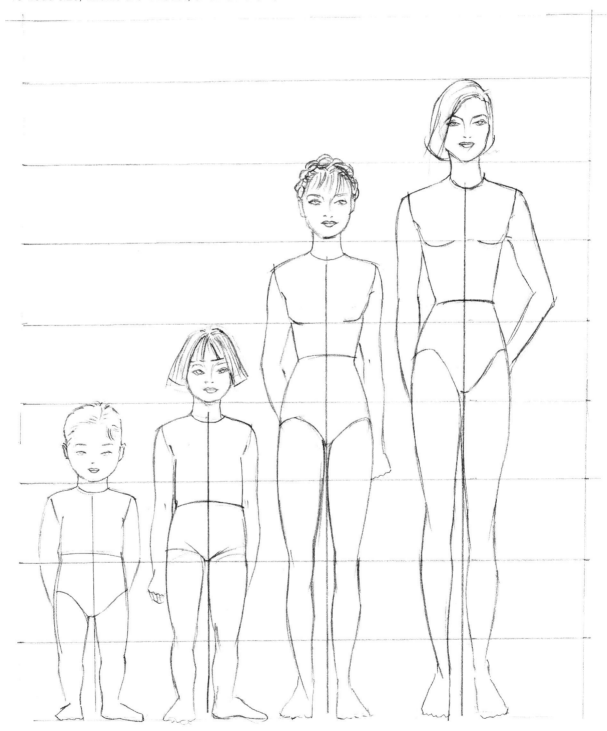

It is important for the figure to be in balance. This can be achieved by using a vertical plumb line for all standing or walking poses. This line drops from the pit of the neck to the centre of balance.

For example, if the model were standing head on with weight equally distributed on both feet, however wide apart, the line would come straight through the figure and be exactly between both feet.

However, in most poses one foot usually takes more weight than the other, so the various horizontal axes shift accordingly: the hip on the weight-bearing side raises as the pelvis tilts towards the non-weight-bearing side. The upper part of the torso above the waist relaxes to lean towards the weight-bearing side, thus dropping the shoulder.

The following illustrations show how to draw a figure in balance, using a variety of different poses and viewpoints.

▶ *Note 1:* The non-weight-bearing leg, the head, neck and arms are free to be placed wherever you wish.

▶ *Note 2:* Shoulders slope in the opposite way to the hips.

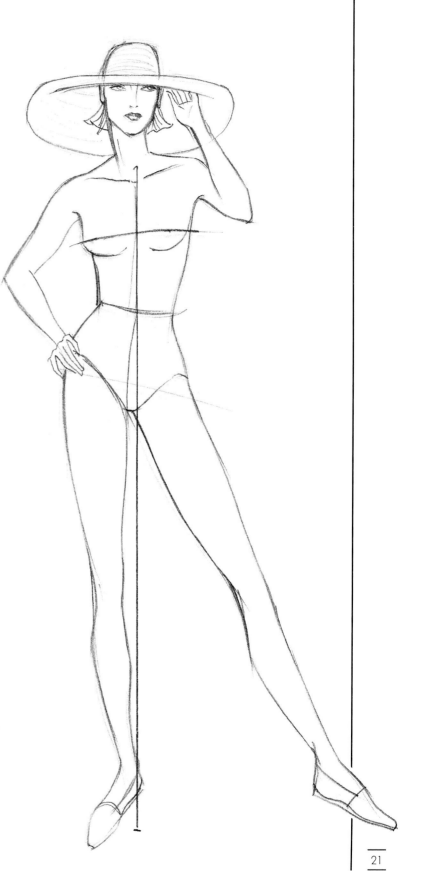

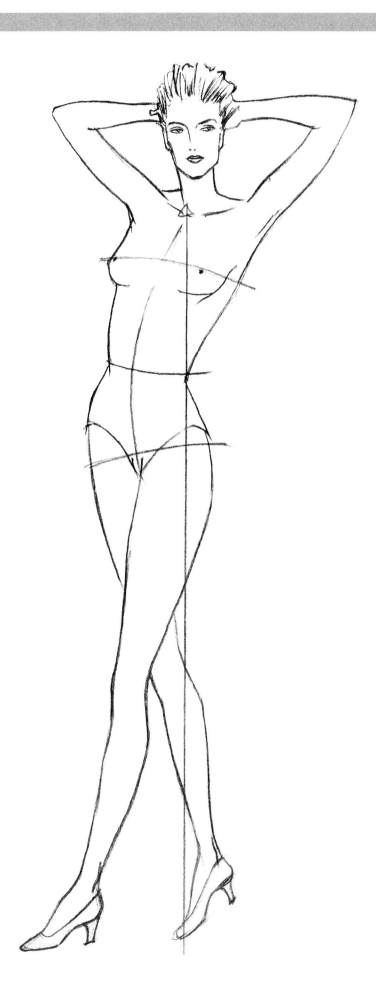

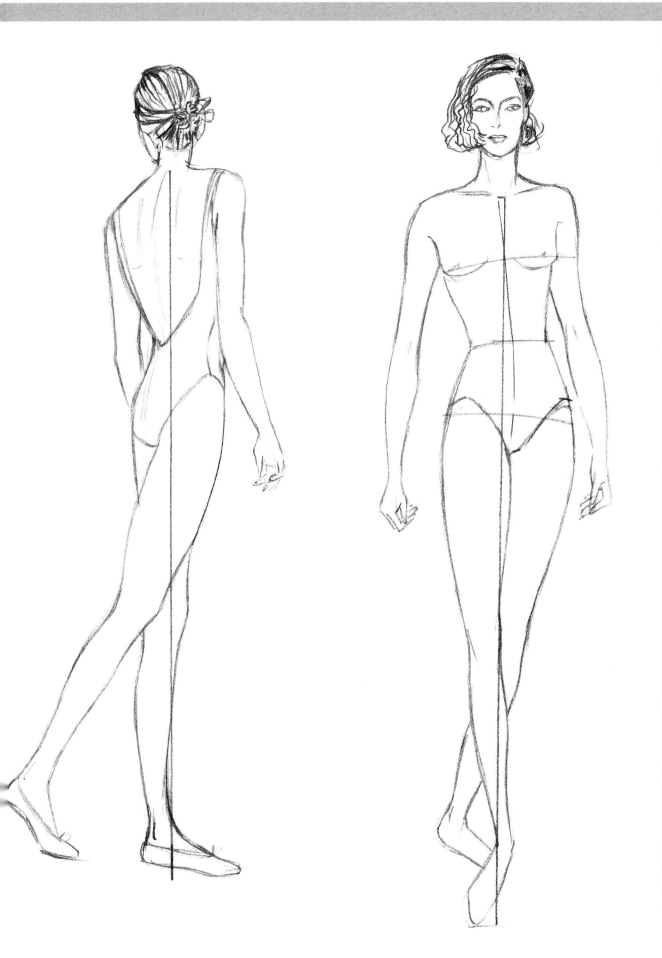

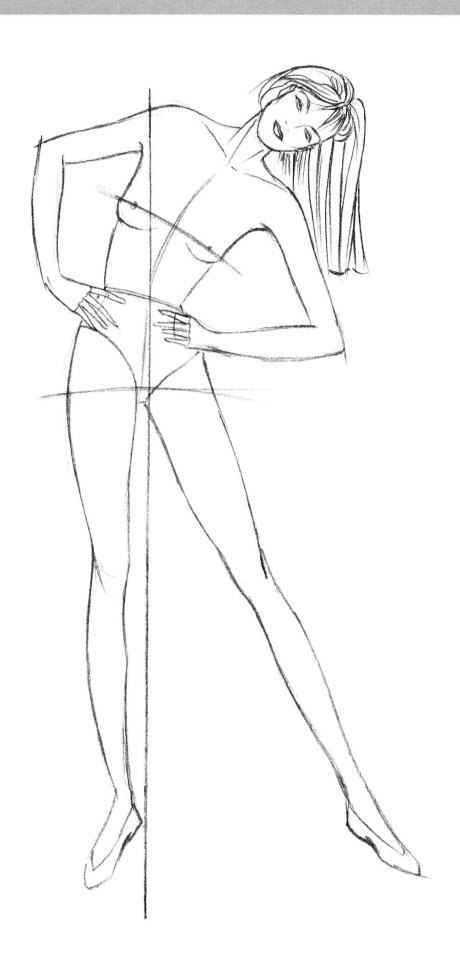

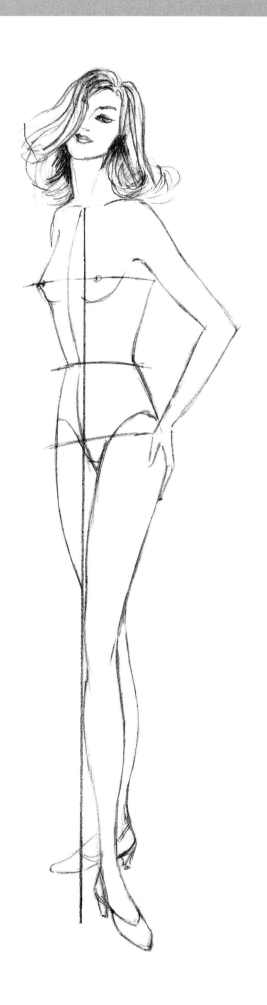

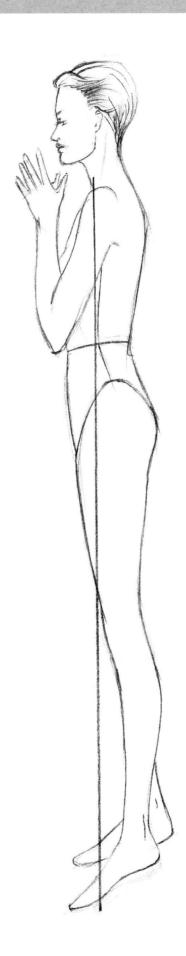

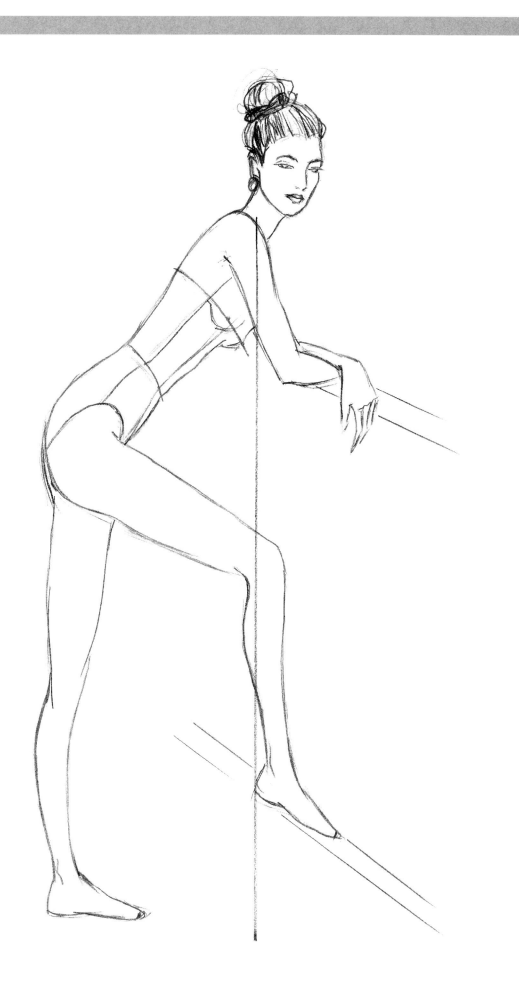

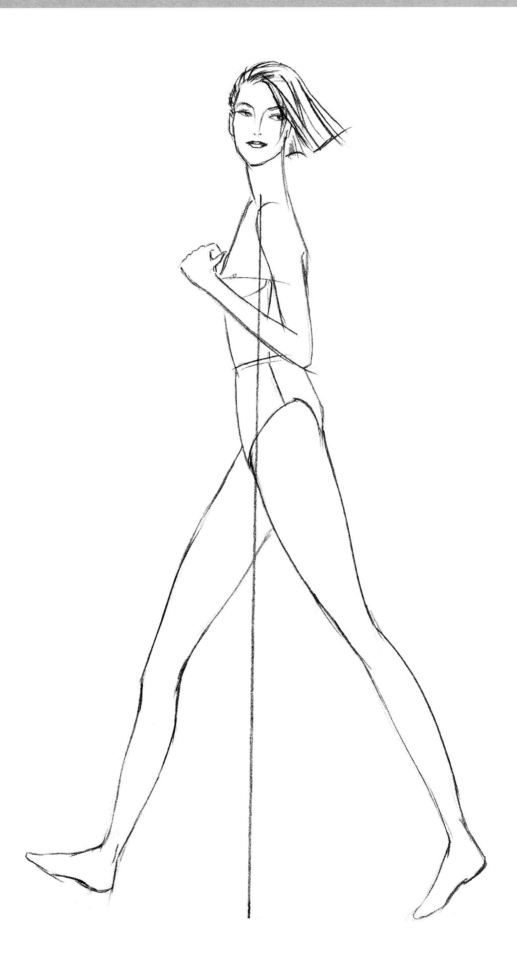

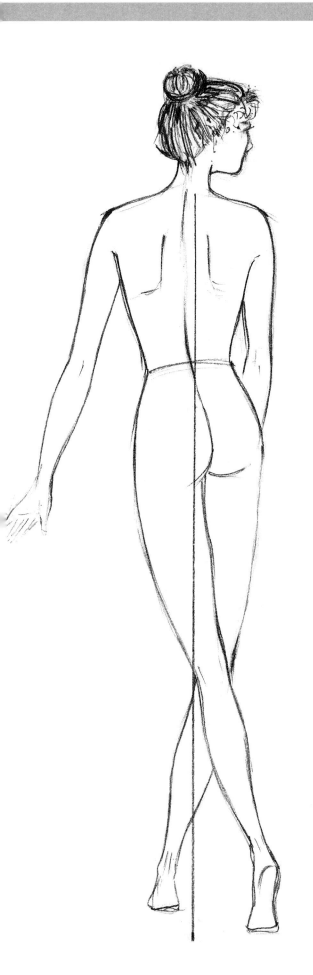
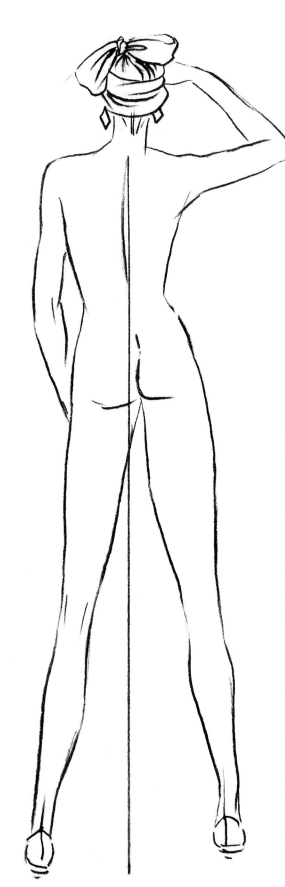

DIFFERENCES BETWEEN MALE AND FEMALE

It should be remembered that an illustration is projecting an image. Men and women, although based on a similar skeleton, fill out quite differently.

The leg elongation still applies for a male fashion drawing but the whole effect is bulkier:

● Jaw squarer
● Neck thicker
● Shoulders broader
● Chest deeper with muscles, not breasts
● Waist wider curving down towards the navel

● Hips narrower
● Codpiece box shape, not pelvic triangle.

Men tend to stand more squarely and are less inclined to accentuate the tilt of the hips.

In movement, mens' elbows are away from the body with hands curving towards the thighs. However, women move with elbows bent towards the hips, often with elegantly outstretched fingers, especially in catwalk poses. Women in movement swing their hips, while men roll their shoulders.

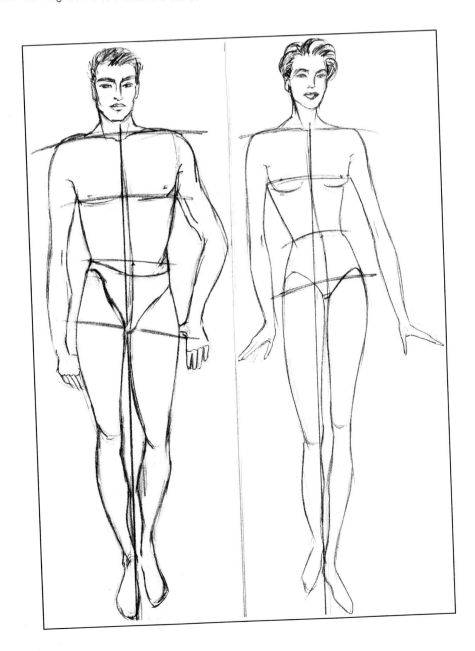

HEADS

It is an inescapable fact that when a person is described as being attractive, the remark tends to refer to their face in the first place, followed by figure, deportment and character. Tastes of course differ, but at any given time there is an ideal to aspire to in all the categories of sex, race, age and form. As a fashion illustrator you are either creating or reflecting this ideal.

The faces drawn are therefore very important to the image the artist is trying to promote.

Beauty is not only skin deep, and to create a perfect face some knowledge of the underlying structure is needed, however much the artist might wish to distort it for his or her own ends. However outrageous the stylization, it will be more convincing if it is originated from the basics.

 Note 1: With female faces make-up can be shown to enhance the eyes, lips and exaggerate the cheek bones. Only thin eyebrows need to be shown.

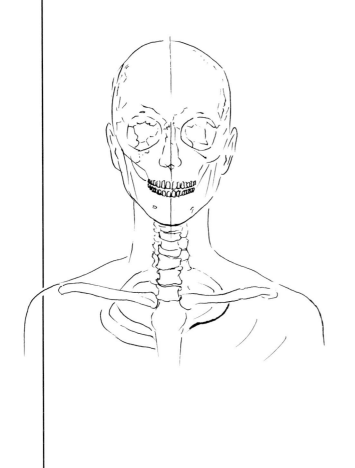

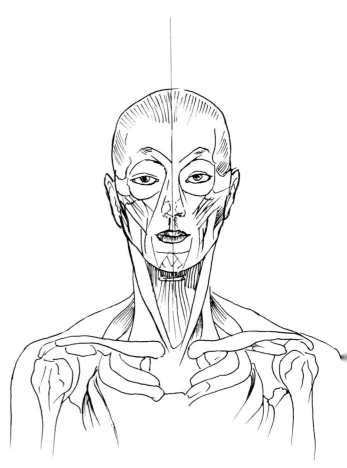

▶ *Note 2:* To give a male head a masculine look the jaw should be squarer, the eyes less exaggerated and the eyebrows thicker. The nose can be made more prominent and the lips less so. A male neck should also be drawn more thickly.

These drawings show the skull and shoulder skeleton, muscle formation, and the packaging of skin. It is worth noting the neck length and slope of the shoulders from all angles to gain an understanding of the relationship between the head and torso.

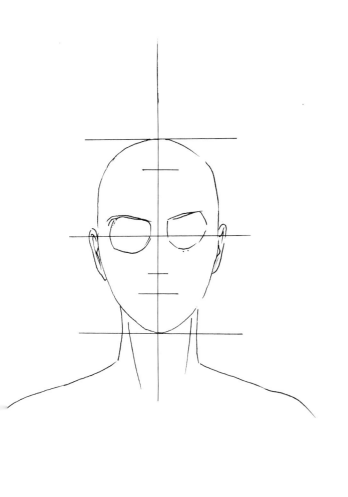

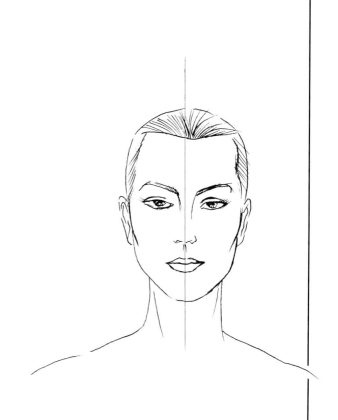

FEATURES OF THE FACE

It is important to note how the features of the face relate to each other and to the head itself. The eyes come half way between the chin and the top of the head.

Dividing the head into three, from the chin to the hairline, finds the level of the bottom of the nose and ears in the lower third and the eyebrows at the top third.

Eyes

The eyebrow marks the top of the eye socket in the skeleton. An almond-shape indicates the form of the eyeball within the socket. The top third of this is the lid and lashes can be shown simply by thickening the line with a slight feathering on the outside edge. Only two-thirds of the pupil and iris are usually visible.

Jaw

Even on a female face, a hint of the squareness of the jaw bone can make the face look more life-like.

Nose

In a head-on view, the nose only needs the slightest of indications, showing nostrils.

Ears

A useful shorthand for ears is a question mark shape '?' with a small 's' inside.

Mouth

Mouths can be shown with three lines. (The gap between the nose and the top of the top lip is about half the length of that between the bottom of the lower lip and the chin). The top lip can be indicated by drawing two flat Ms joining at the corners. The lower lip need only be a very flat U-shape with an optional inverted U under it to show the shadow. An open mouth is achieved by dropping the jaw to reveal just the front top teeth. The top of the lower lip is an even shallower, softer M and all four delineations meet at the corners.

Note 1: The above tips are shorthand, but variations can be sought through observations. It is sometimes worth making more of a feature of the face and even producing almost a portrait. This can give a drawing character and make the whole figure look more human.

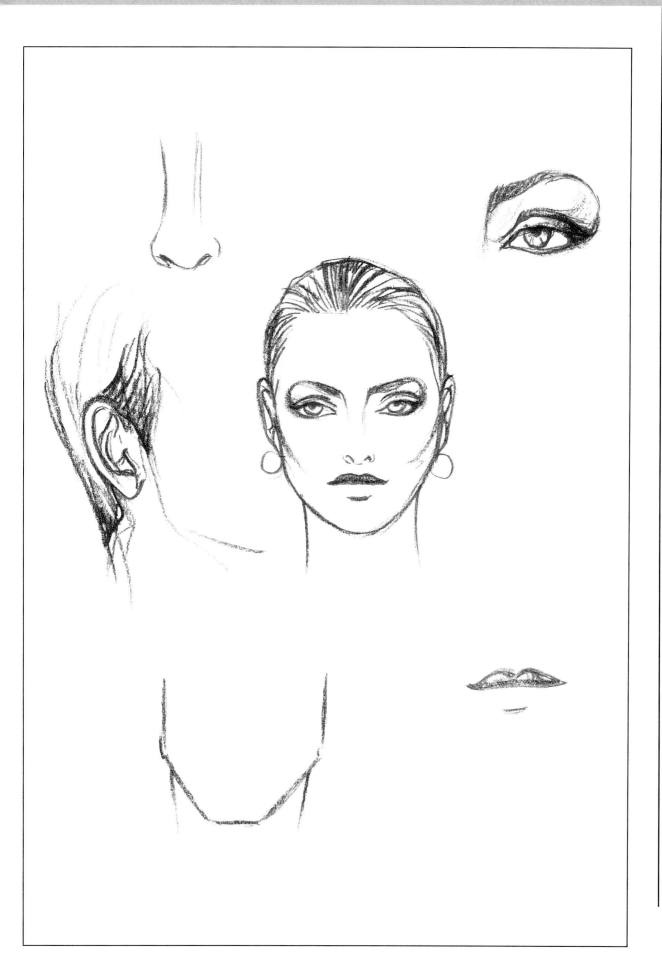

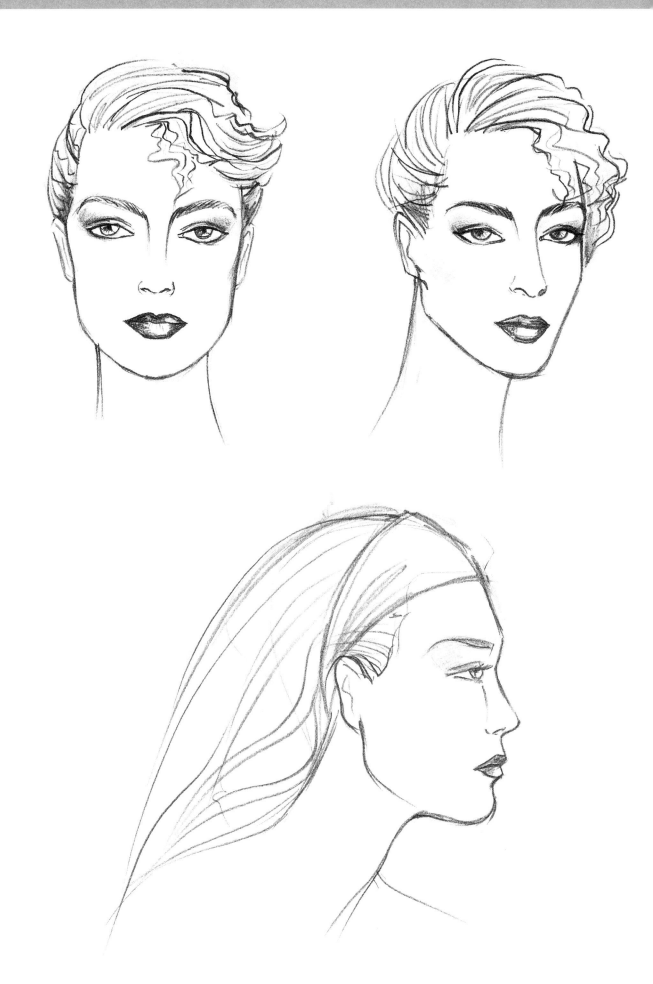

FACES IN MOVEMENT

Again, age and sex require different treatment.
These drawings show some variations as well as
the possibilities presented by hair-styling. These, of
course, can be swapped about as creatively as
possible: long hair; loose or pony-tailed; shaved
heads; dreadlocks; Afro; plaits; wigs; outrageous
colours.

If the total look works anything goes — but to
put forward the concept, the artist must first be
able to draw it.

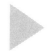
Note 1: Try not to over-draw the hair
as this may unbalance the emphasis of
the illustration as a whole.

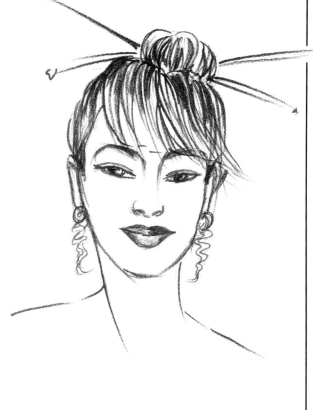

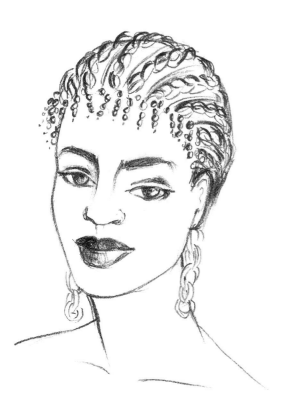

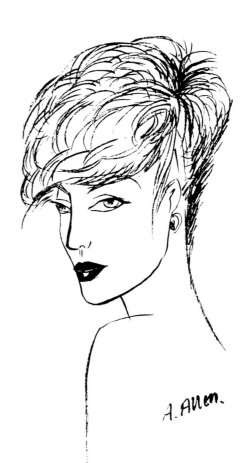

HANDS

Having covered the basics of perhaps the most important part of a drawing — the body and the face — an illustrator must face up to the task of drawing the hands and feet. The proper execution of these extremities can make or break an illustration.

Hands are difficult to draw, but no illustrator can spend their career resolutely stuffing them into pockets or concealing them behind the back.

Here are some hand poses which should help with back, front and gripping positions.

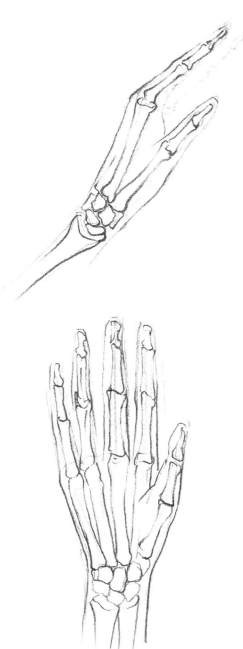

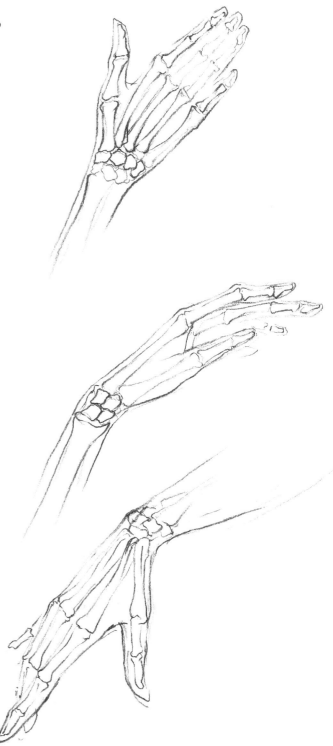

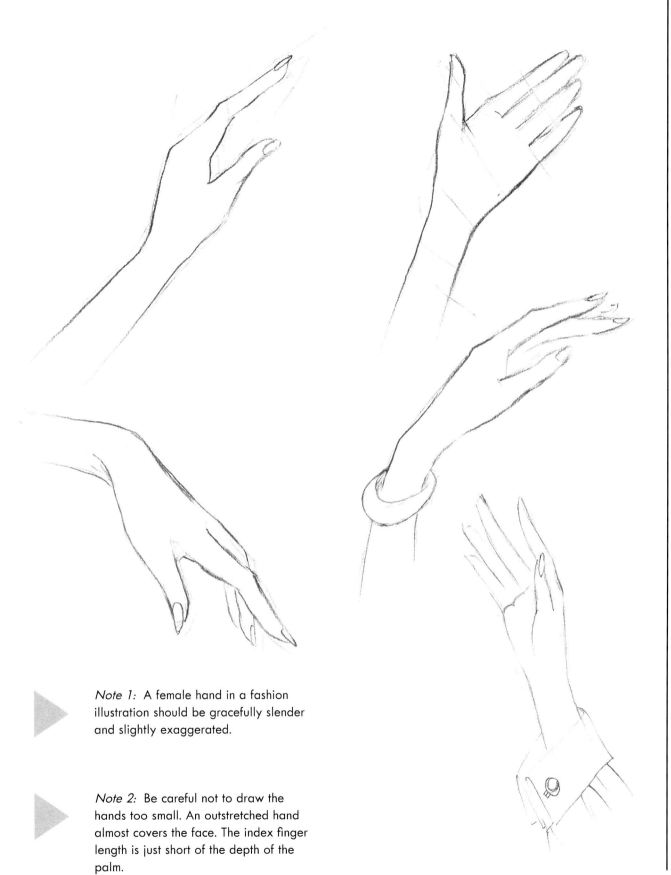

Note 1: A female hand in a fashion illustration should be gracefully slender and slightly exaggerated.

Note 2: Be careful not to draw the hands too small. An outstretched hand almost covers the face. The index finger length is just short of the depth of the palm.

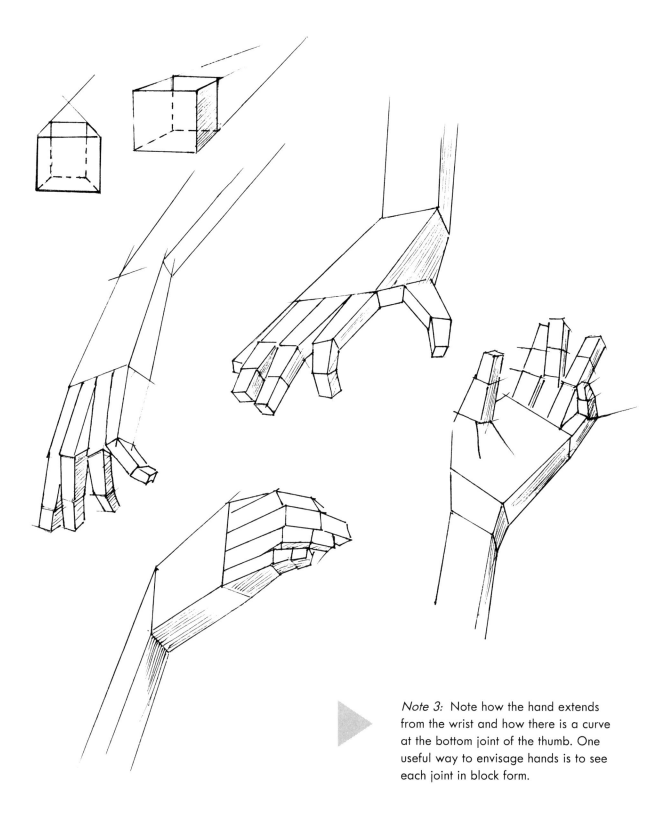

Note 3: Note how the hand extends from the wrist and how there is a curve at the bottom joint of the thumb. One useful way to envisage hands is to see each joint in block form.

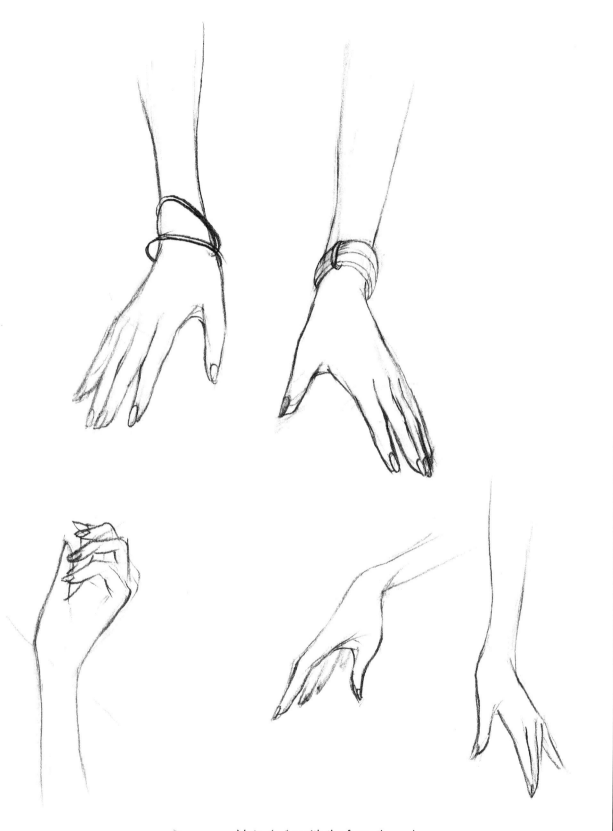

Note 4: As with the face, the male hand is squarer and without longer nails. The fingers should be rounded at the top.

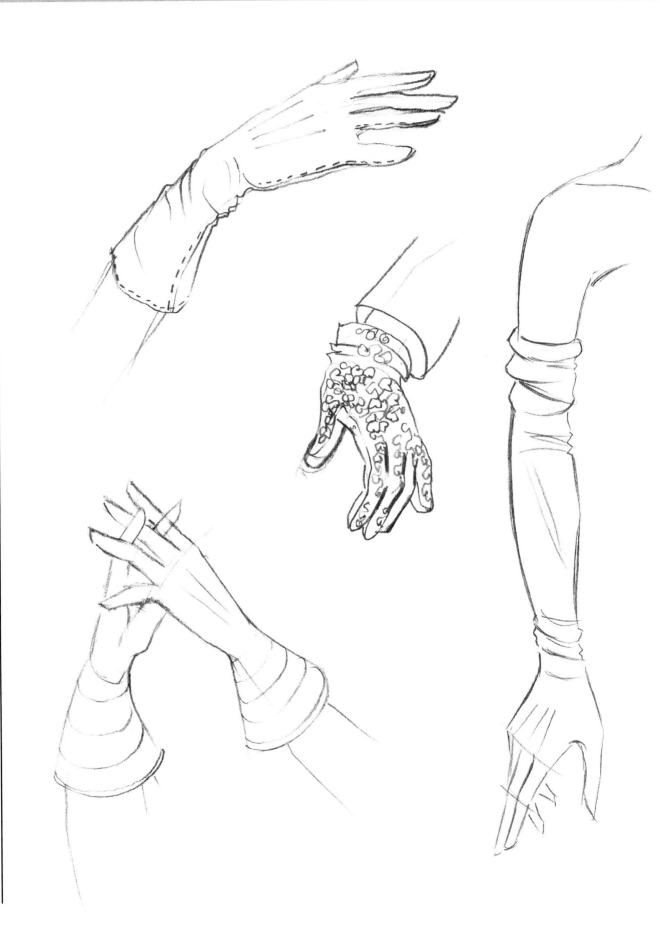

Whereas hands will most usually be shown naked, it is unusual for a real or invented model to be barefoot. Nevertheless, an understanding of how to draw an unshod foot is essential, since the weight distribution, and thereby the shape of the standing body, entirely depends on foot position. The overall effect of foot position will become apparent in the finished drawings. Many of the following drawings show basic flat poses, but since shoes often have some sort of heel, this will affect the posture in relation to the height of the heel as well as the appearance of the foot itself.

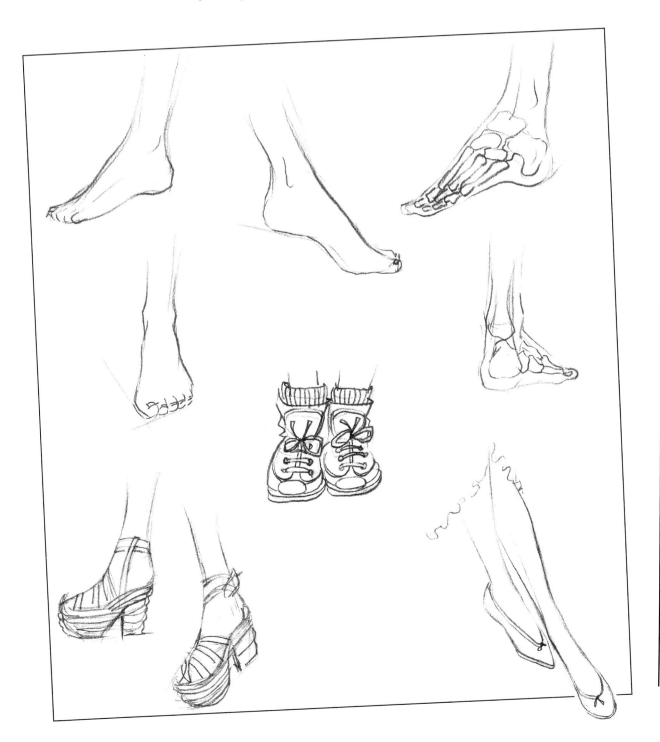

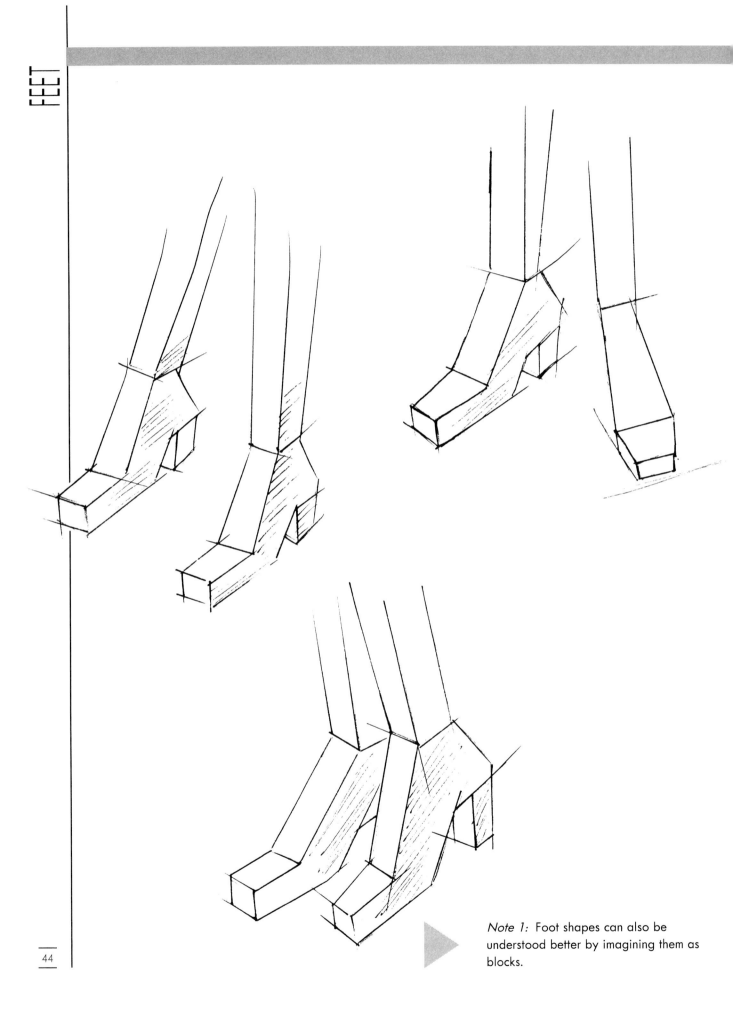

Note 1: Foot shapes can also be understood better by imagining them as blocks.

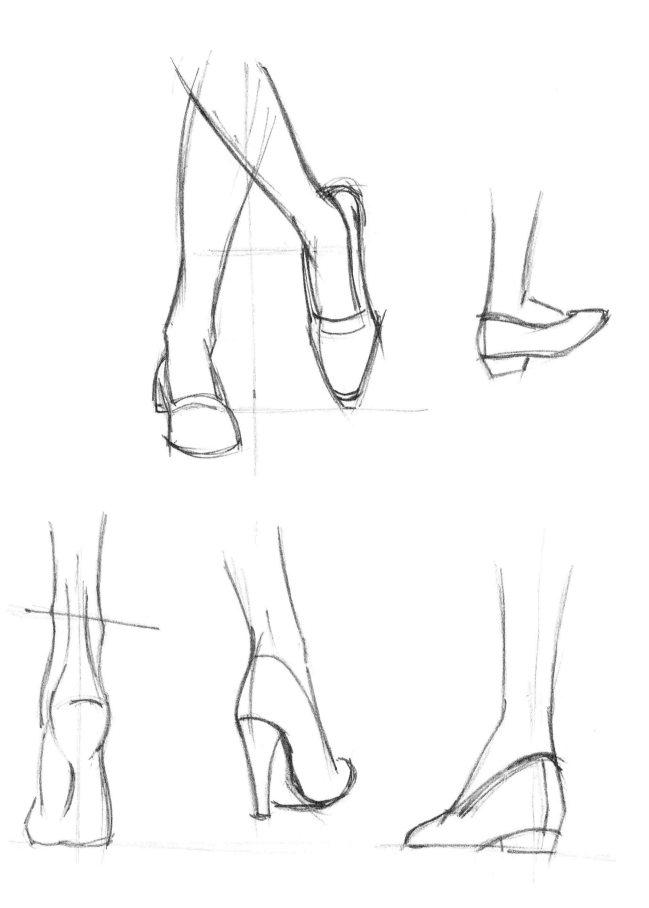

Note 2: Notice how the foot extends from the lower leg. The curves that occur from the bump of the ankle; the arch on the inside; the slope on the top of the foot which becomes more pronounced as the height of the heel increases. Bulky fat-soled boots and trainers almost disguise the actual shape of the feet.

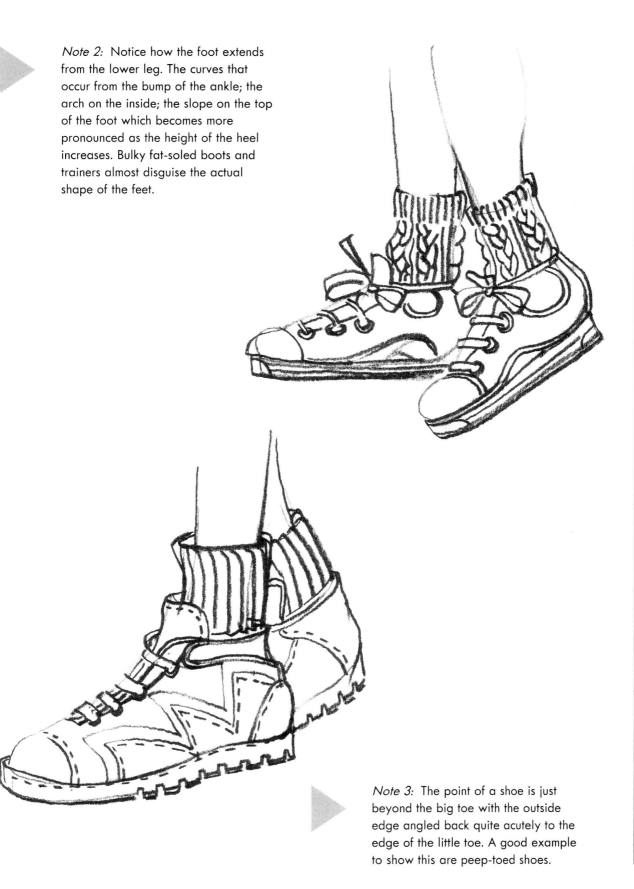

Note 3: The point of a shoe is just beyond the big toe with the outside edge angled back quite acutely to the edge of the little toe. A good example to show this are peep-toed shoes.

47

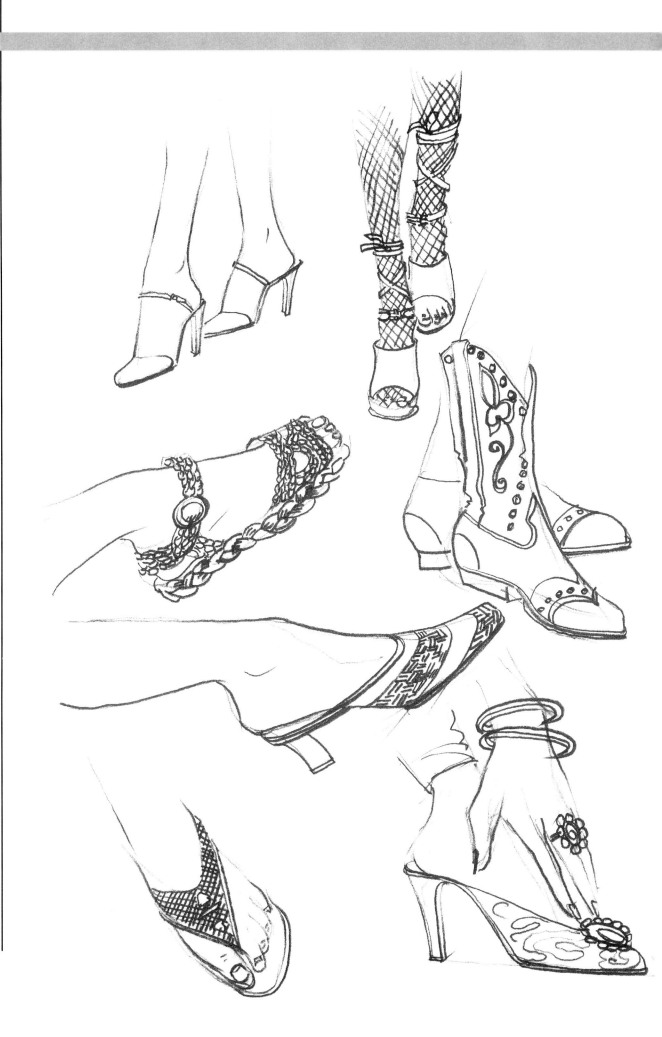

However good a drawing, it should also sit comfortably on its page, giving a pleasing composition. Background shapes, props and settings can also enhance the 'look'. The top margin should be smaller than the bottom margin. The composition should be in balance with the side margins. The figure should be large enough not to get lost in a corner of the page, but not so large that the head or feet are off the page (except in stylized illustrations where this is deliberate).

Unless a drawing incorporates a composition of several figures, the paper will best be used 'portrait' (longways) and not 'landscape' (sideways).

The figure must be *scaled* to fit the page, and the parts of the body drawn in *proportion* to each other.

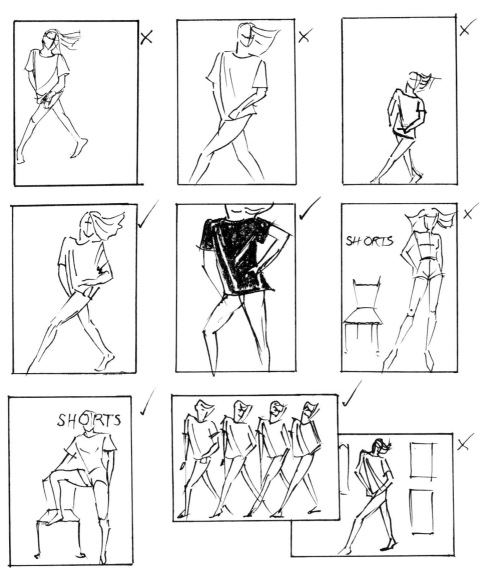

Note 1: When adding background props or shapes to a drawing, they should be linked to the figure and not just be isolated on the page.

LIGHT SOURCES

In fine art illustrations there may be light sources which lead to complex shadow formations. In fashion drawing a single imaginary source at right angles to the figure can be imagined to cast a basic shadow which indicates solidity. This will accentuate the folds, hang and textures of garments. By using a figure template (see examples later) a free drawing can be made by firmly drawing the accents as opposed to just the contours of the dressed figure. These accents should have start and finish destinations, and be boldly expressed.

 Note 1: Examples of areas to accentuate: the suggestion of a bustline: folds at the bend of the arm: the folds and gathers caused by a belt; stress folds at the crotch, armpit, knee and the cuff.

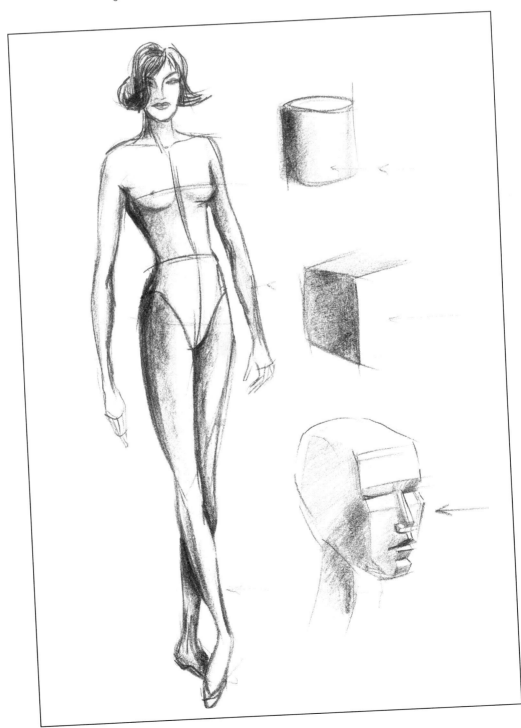

The previous sections have shown how the body moves and balances, how to draw heads, hands and feet, and the development of some basic poses. Next the illustrator should move on to understand how different garments and fabrics hang, and how they will look when drawn. A garment often suggests a particular pose.

neclines and collars; waistlines; sleeves, as well as working on the various basic shapes: jackets; skirts; trousers; blouses; sweaters or dresses. The following drawings show a selection of details and basic garments.

It is helpful to explore how individual areas of a garment can best be illustrated, for example:

Note 1: Most clothes are variations on a cylindrical shape.

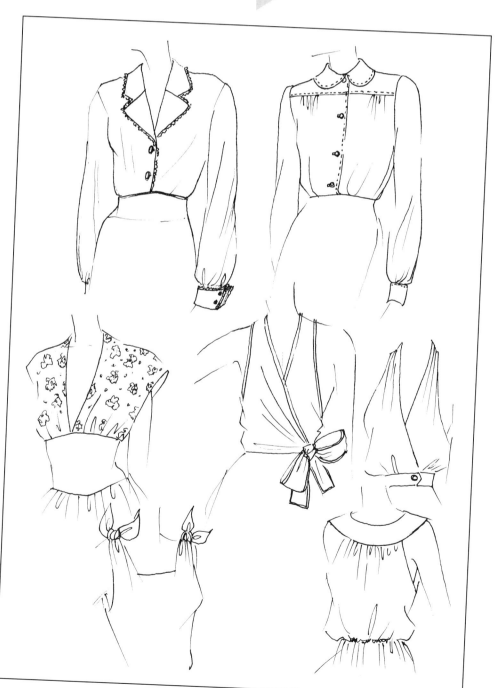

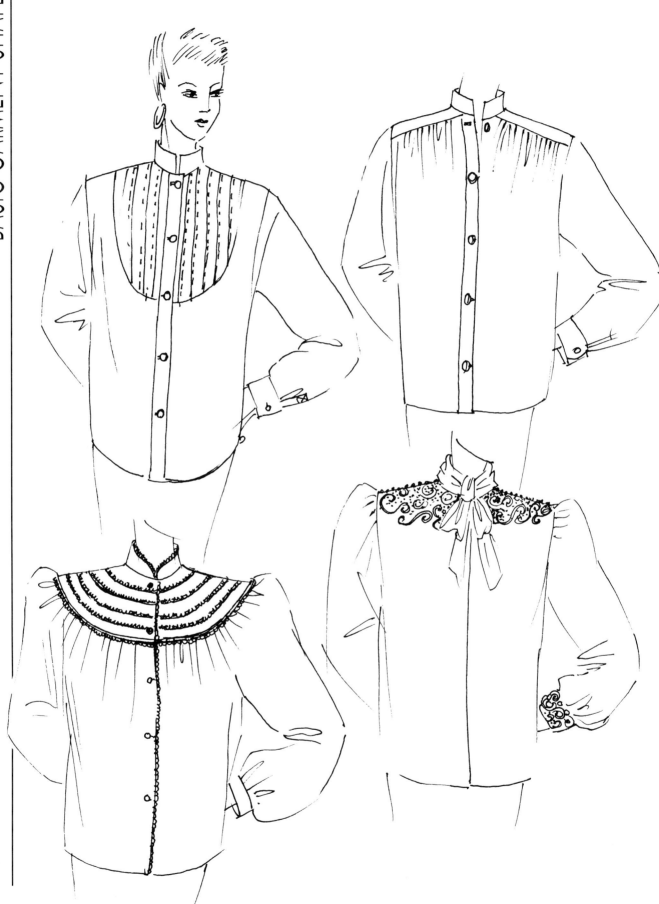

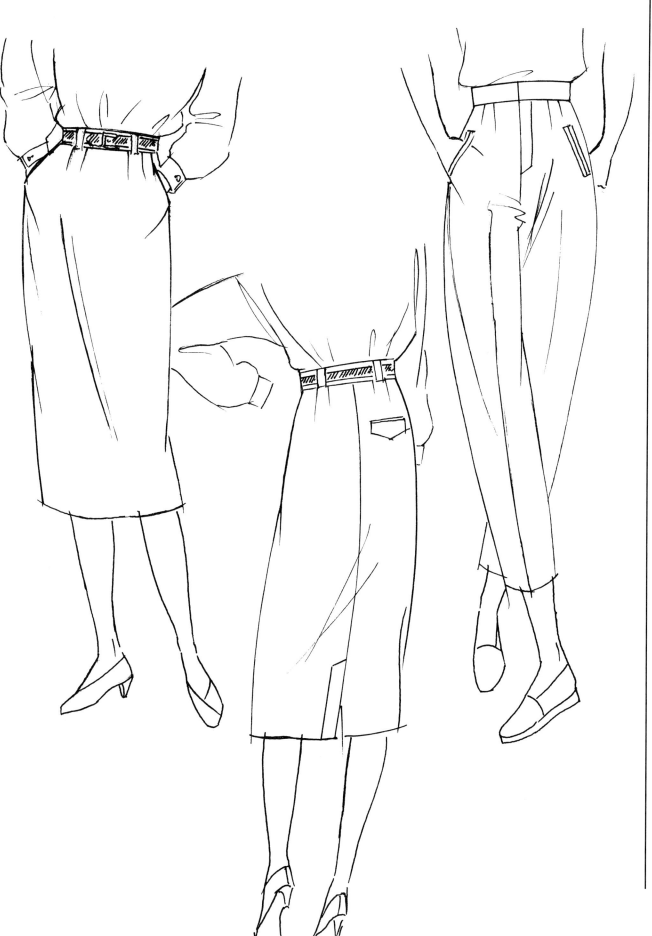

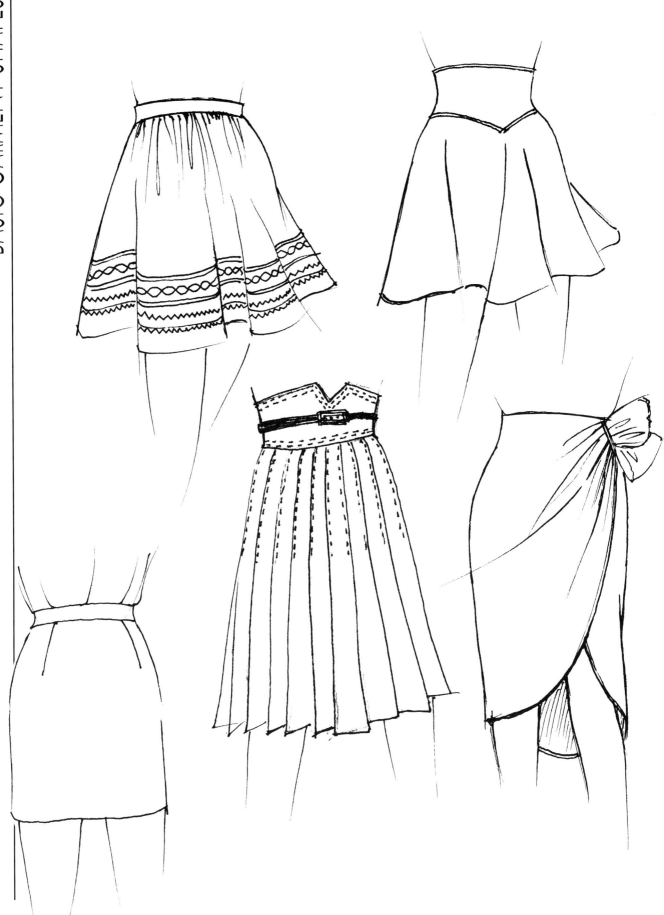

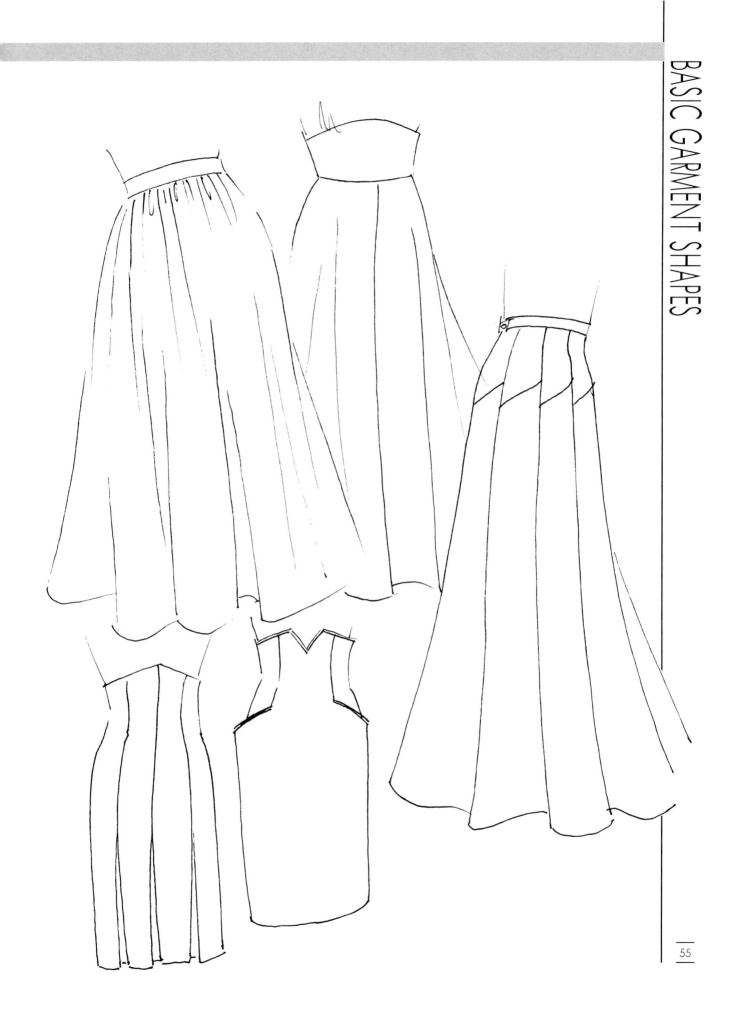

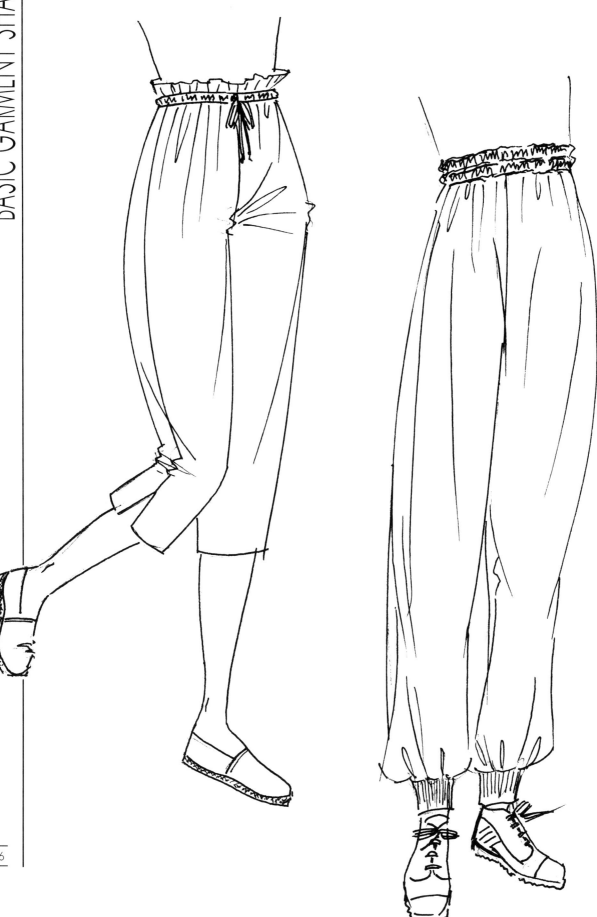

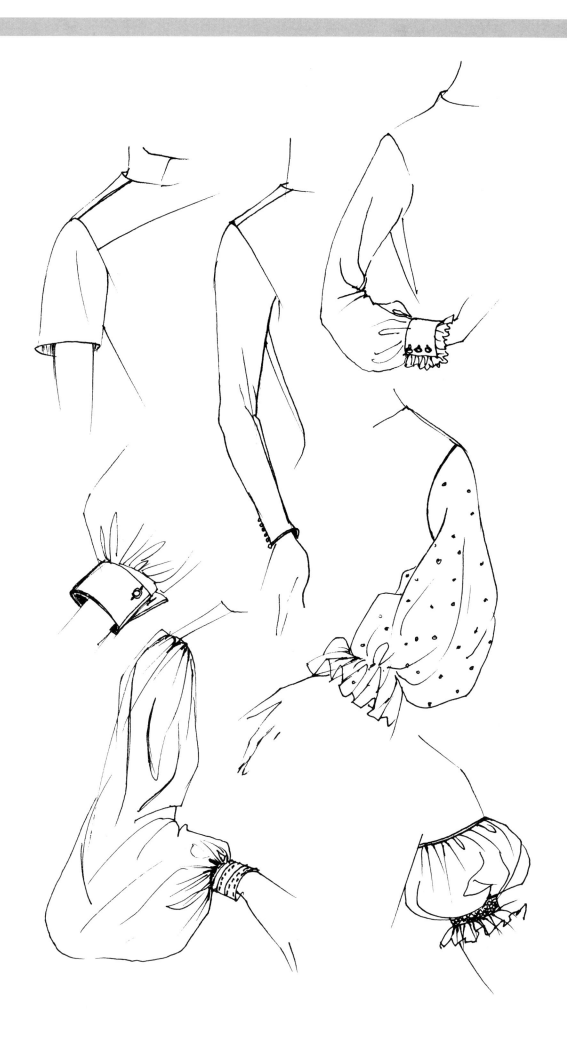

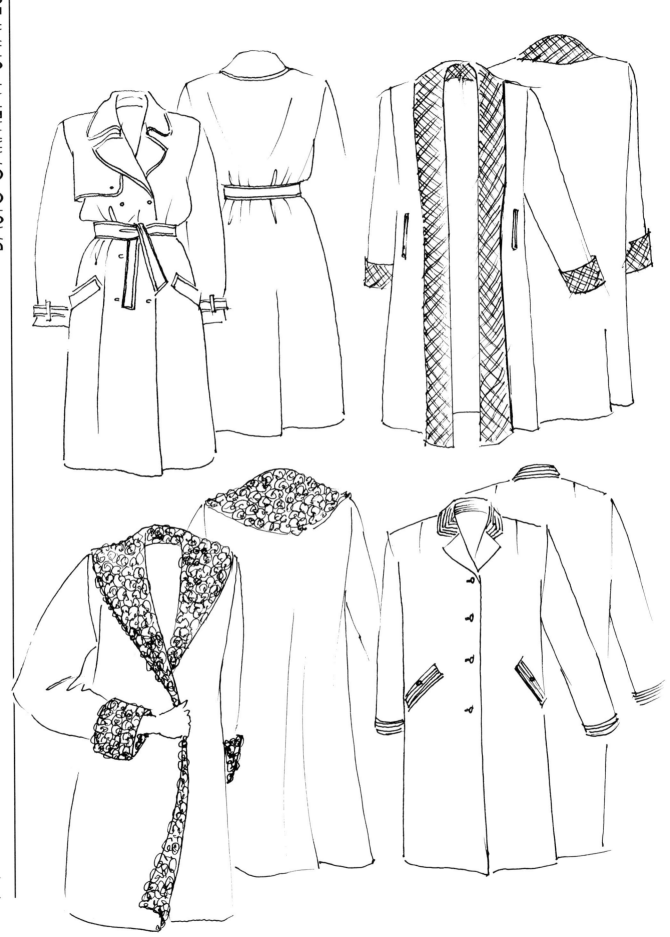

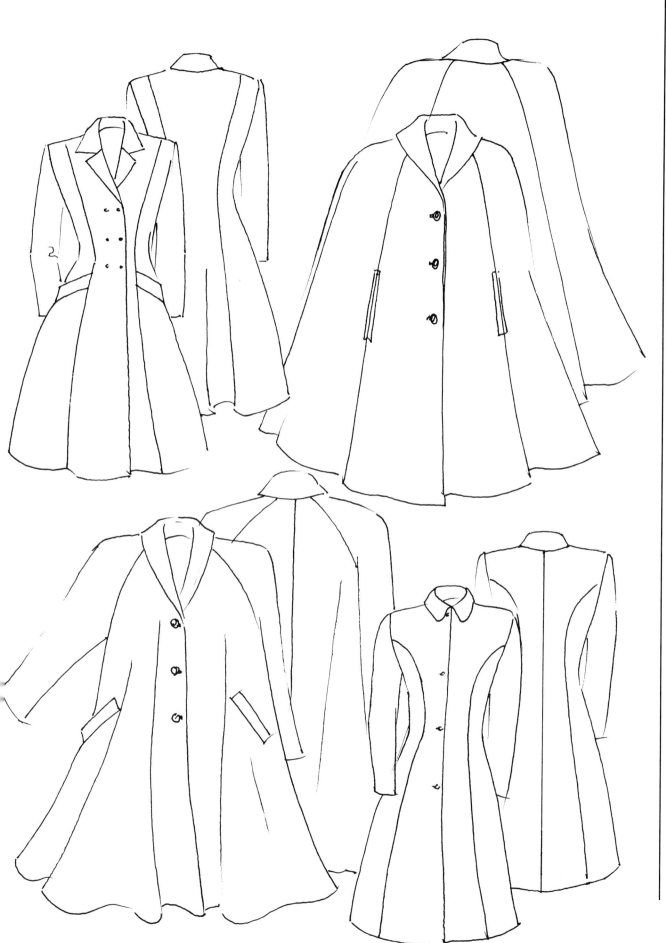

ACCESSORIES

Accessories can make or break a 'look', be they
belts, hats, bags, shoes, shawls, gloves, jewellery
or fashion spectacles. Here are some basic ideas
and examples of how different accessories fit or sit
on the model.

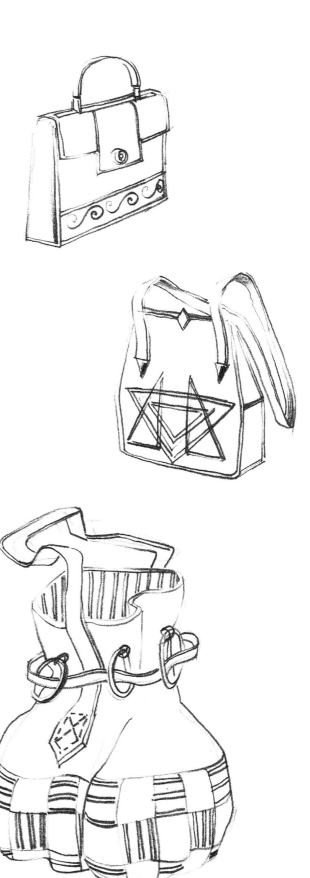

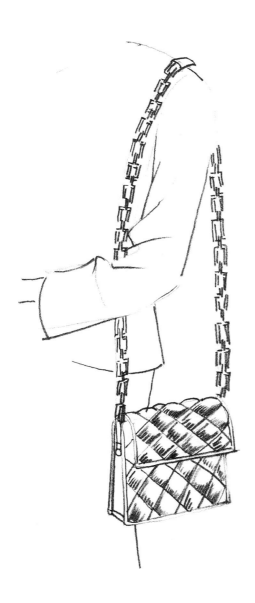

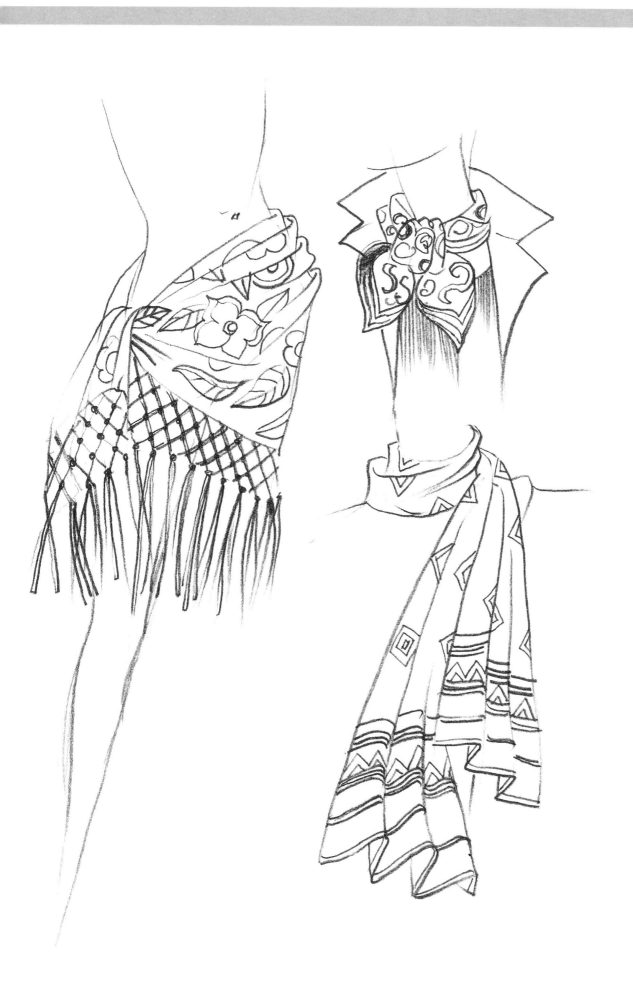

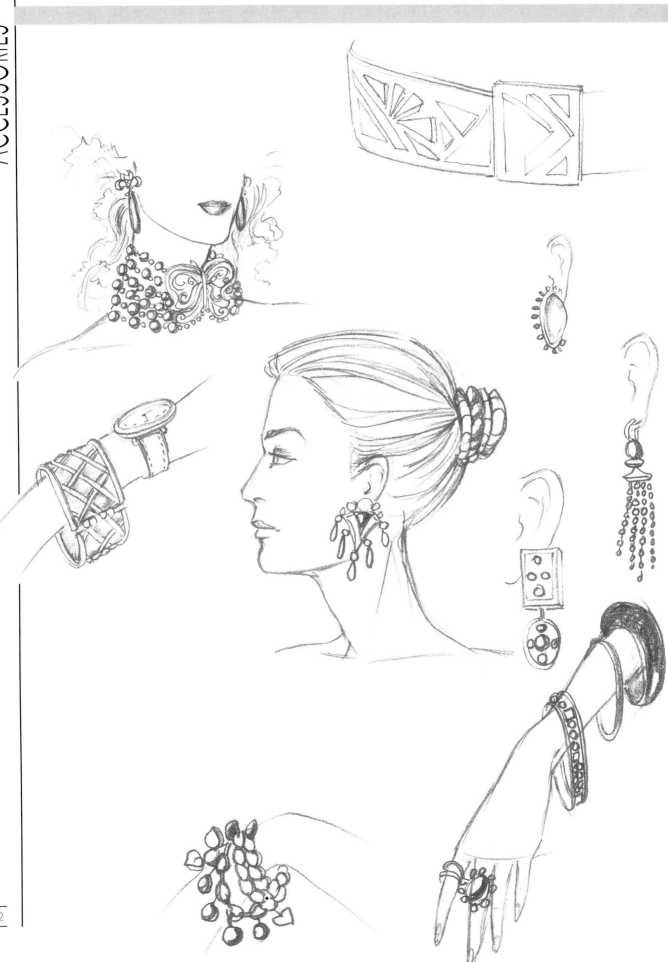

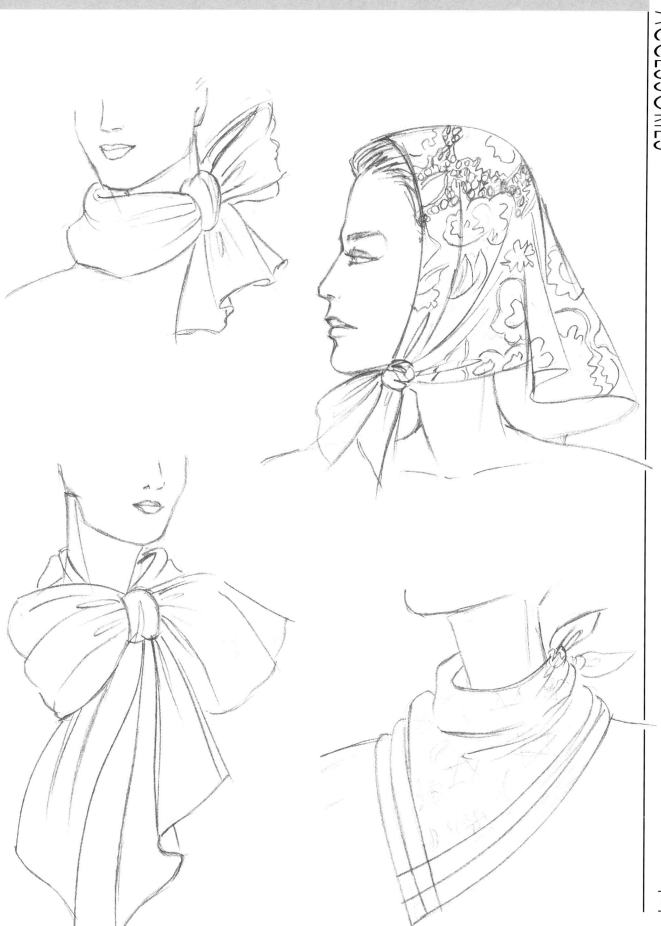

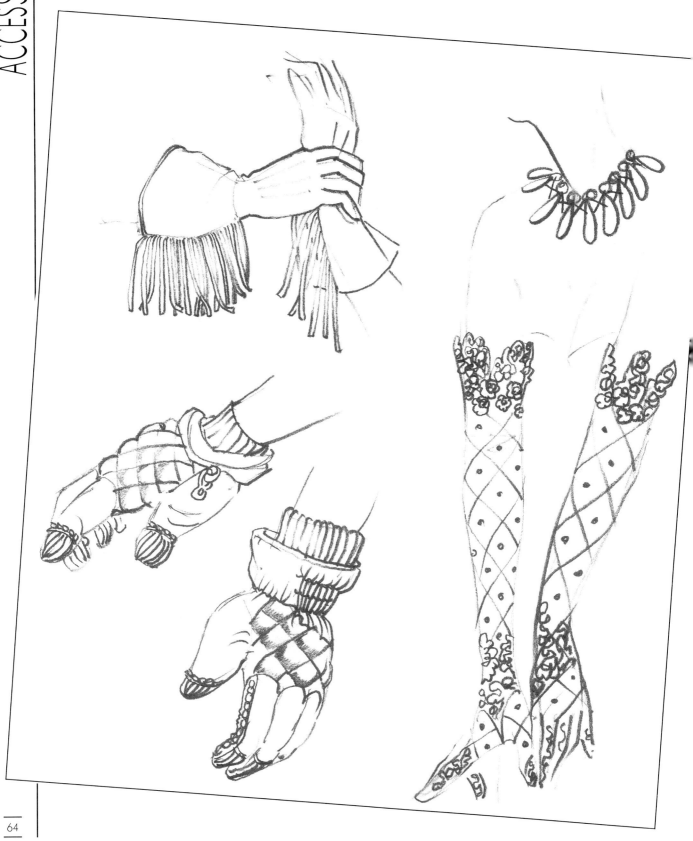

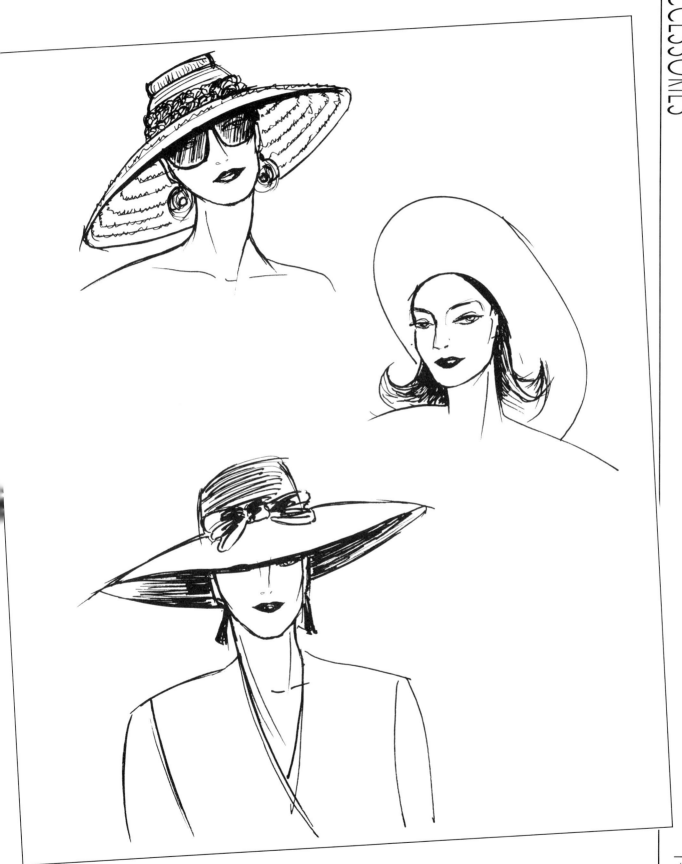

Photographs can be a very useful source of poses and action drawings. Movement of a model often allows a garment to be shown off to the best effect. Just tracing from a photograph, however, will not include the elongation of the legs, so it should only be used as a guide. The plumb line technique is used again, and the photograph clearly shows the tilts of the horizontal axis. Use these as a guide.

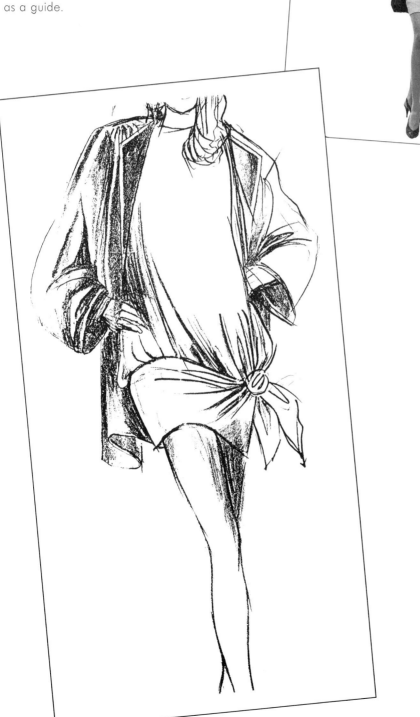

Note 1: If using this method to produce a faithful representation of a designer's total look, all accessories and styling, such as hair, should be indicated. However, if the photograph is merely being used as an aid to a pose for similar design ideas, subtle changes can create a totally different look.

Note 2: For practice, the same method can be used by doing different versions of an existing fashion illustration. The figure will already have been elongated. The artist will already have used the shorthand for the materials and accessories so possibilities for a personal interpretation are more limited, but it can be a useful exercise to attempt other artists' styles before your own individual one emerges.

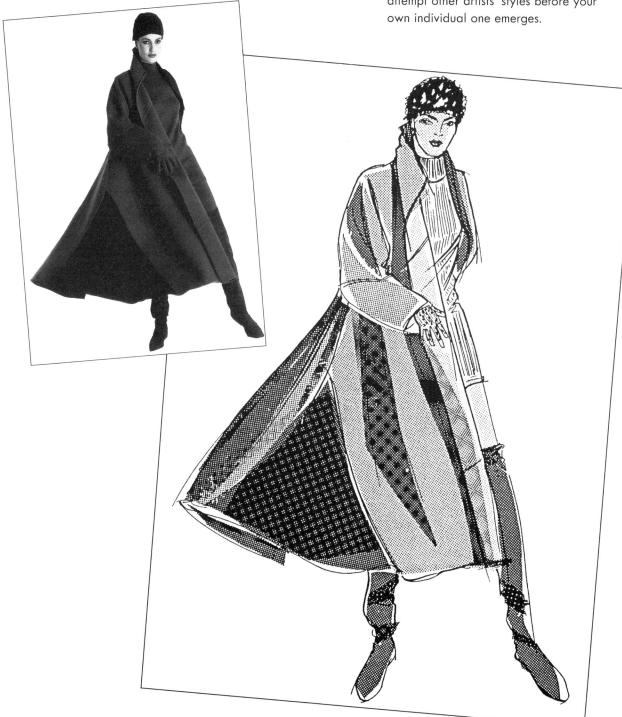

Tracing from an existing drawing — a template — onto layout paper, has many useful functions at all stages. This is in no way cheating, although a finished fashion illustration would normally be on better quality paper.

From the earliest studies of the skeleton the artist can then trace on the muscle layer and the final filling out. Doing this will help to develop an understanding of the basic make-up of the body.

Tracing some favourite poses which have been worked out for unclothed bodies can then be used as base drawings to experiment how clothes will hang on them.

With a base drawing pose, very quick design ideas can flow without having to worry about the figure's proportion and balance for each sketch.

Rapid minor changes to a design can be made, e.g. longer hem, different sleeves, with a rough sketch for each.

Note 1: Both for showing a confident sense of line, and having a record of previous ideas and attempts, it is better with fashion illustration not to rub out or correct a drawing as the result will look laboured. Keep the rejected idea and start again. (See quick poses). Only complete disasters need go into the bin.

Note 2: If tracing direct from a photograph the elongation needed for a fashion drawing will be lost.

DIFFERENT MEDIA

The most universal medium is pencil on white paper. But in the search for creativity anything goes, provided the illustrator can master it. Experimenting is very worthwhile.

1. Layout paper is cheap and usefully semi-transparent, so quick new ideas can be traced from the initial concept with changes to dress length, sleeve shapes, collars and accessories as fast idea drawings for purely personal use.

2. Different grades of pencil can be used for different effects.

3. Water-soluble pencils and felt or fibre-tipped pens also offer great scope for experimentation.

This is where the design drawing will begin to move away from illustrative representation of an existing garment, and where the presentation becomes as important as the content.

4. Try experimenting with different coloured or rougher textured papers.

5. Use water-resistant wax crayons and then brush over with thinly mixed watercolour or gouache.

6. Rip strips of coloured tissue paper glued to your original background colour and draw over in felt-tip, pastel or paint.

7. Make use of rub-on or adhesive tone, in dots and blocks.

8. A bold piece of artwork can be achieved by cutting out colour blocks or images and incorporating them into the design of the page to compliment the drawing. Collaged lettering can also give the impression of a 'published' piece of work.

9. The illustration can all be done with cut out shapes.

It can be productive to experiment with large sheets of paper and a bold approach, and let self-expression take a hand, without worrying too much about the end result. When returning to the smaller page the freedom learnt on the larger scale can produce ever more confident results.

An overall look should be planned before a commitment is made to colour and texture. A well-executed pencil drawing can be ruined by being 'coloured in', whereas a rough sketch can be built-up into a good piece of art work.

MATERIALS.

GRADES OF PENCIL

HB PENCILS
AND
BRUSHES

2B

4B

1

3

6

KNEADED ERASER

PENCIL ERASER

PENCIL ERASERS

TRACING PENCIL

CARBON PENCIL

MAGIC MARKERS

COLOURED INKS

CARTRIDGE PAPER.

LAYOUT PAD.

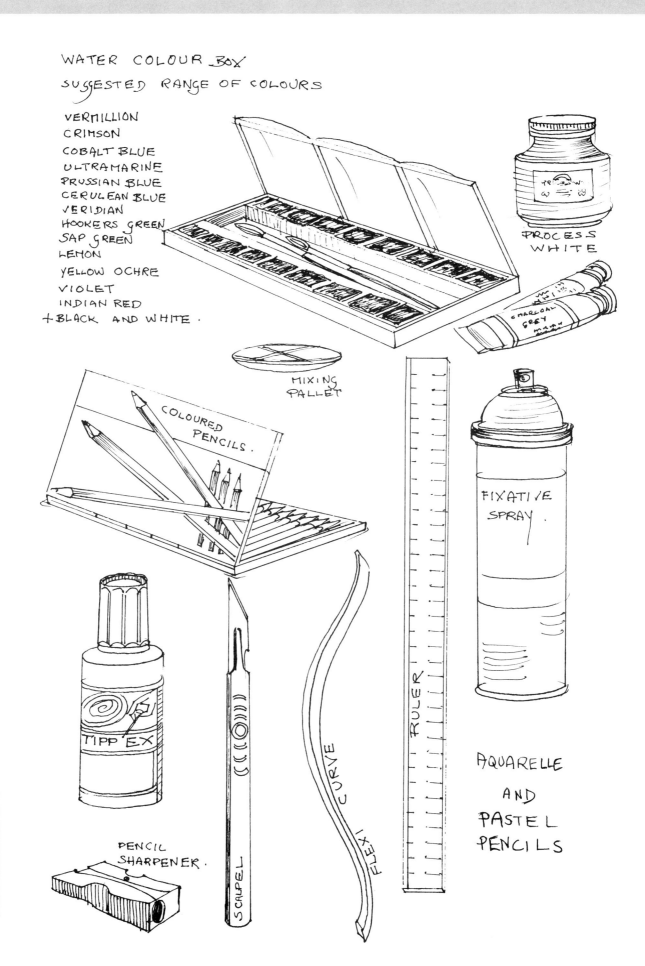

WATER COLOUR BOX
SUGGESTED RANGE OF COLOURS

VERMILLION
CRIMSON
COBALT BLUE
ULTRAMARINE
PRUSSIAN BLUE
CERULEAN BLUE
VERIDIAN
HOOKERS GREEN
SAP GREEN
LEMON
YELLOW OCHRE
VIOLET
INDIAN RED
+ BLACK AND WHITE.

PROCESS WHITE

MIXING PALLET

COLOURED PENCILS.

FIXATIVE SPRAY.

TIPP EX

PENCIL SHARPENER.

SCALPEL

FLEXI CURVE

RULER

AQUARELLE AND PASTEL PENCILS

Different materials not only behave differently, but — without resorting to mixed media — each needs a form of shorthand to describe it: silk, tweed, fur, corduroy, knit, print, leather or lace. Examples of these are given in the following drawings.

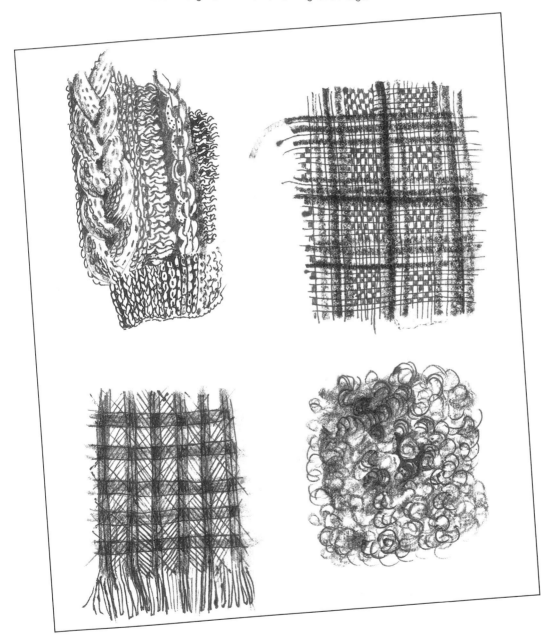

Note 1: The illustrator should remember the contours of the body when 'filling in' a drawing with texture or print.

Note 2: A drawing need not be completely 'filled in' with a pattern or texture — a selective indication often looks less laboured and gives a lighter feel to the drawing.

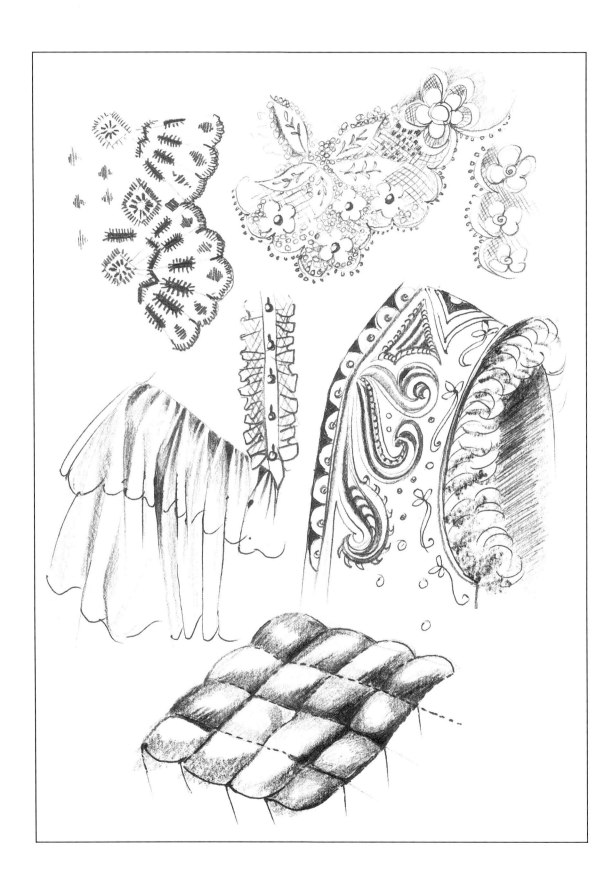

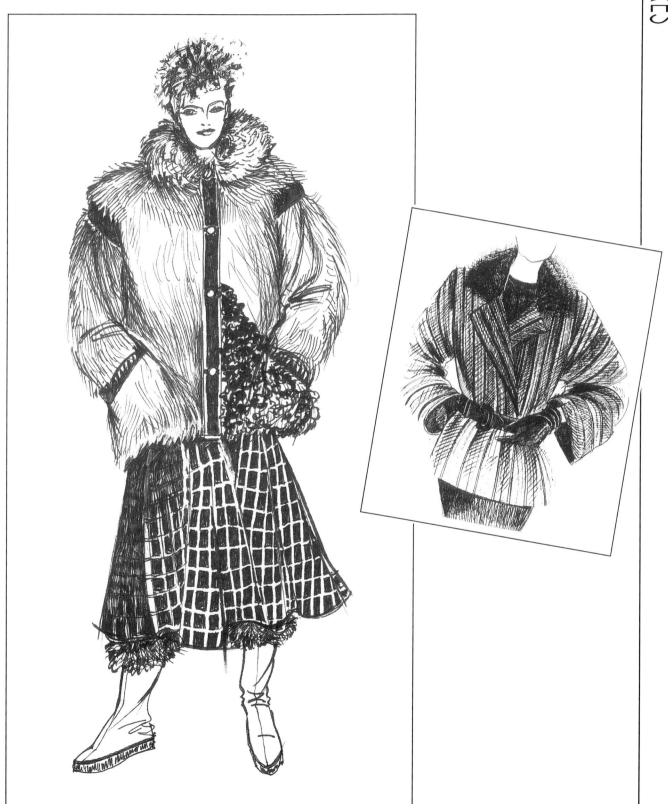

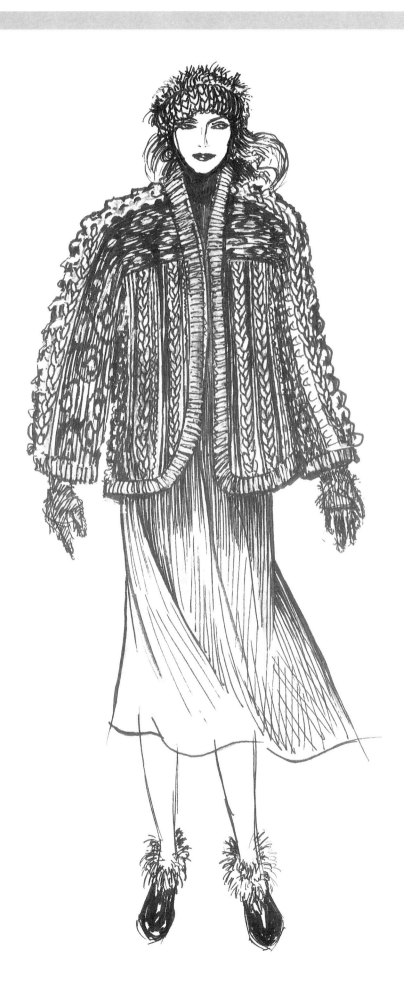

For a design project a concept storyboard may be the basis for ideas. This can consist of a large sheet of card pasted with photographs, postcards, colour blocks, fabric swatches and any other forms of inspiration for a particular theme.

This can be part of a design package, which will include working drawings.

In clothes design there is a time to put 'style' away, and demonstrate the ability to draw practical illustrations for 'in house' use by the pattern cutter. These are the bread-and-butter drawings of the industry, but absolutely vital to ensure that the flamboyantly conceived idea actually ends up looking as it is meant to. Here there is no escape from back views, as measurements and details all have to be noted. These drawings will usually be accompanied by sample swatches of the fabrics to be used.

This technique can be practised by using clothes laid out on a flat surface. Note all the measurements, details, construction and stitching lines.

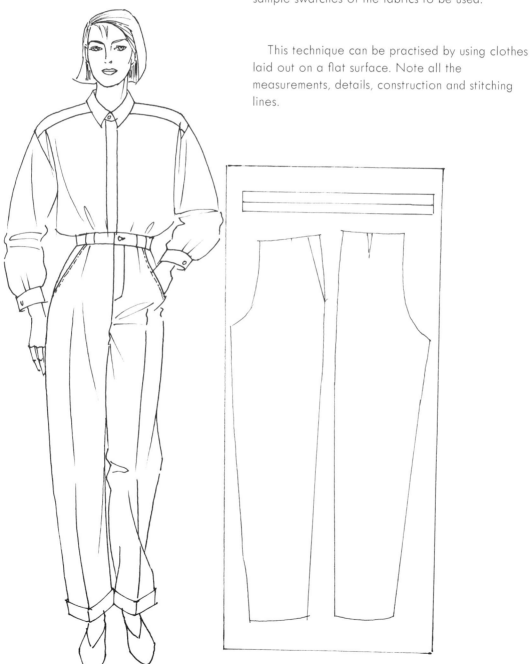

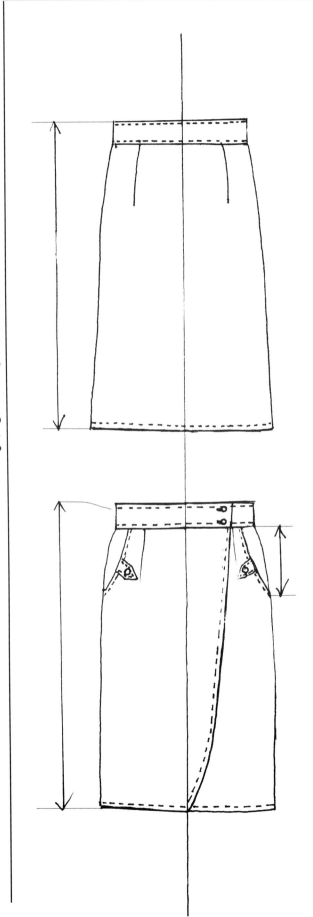

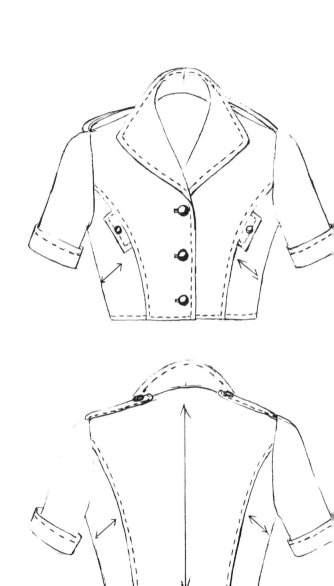

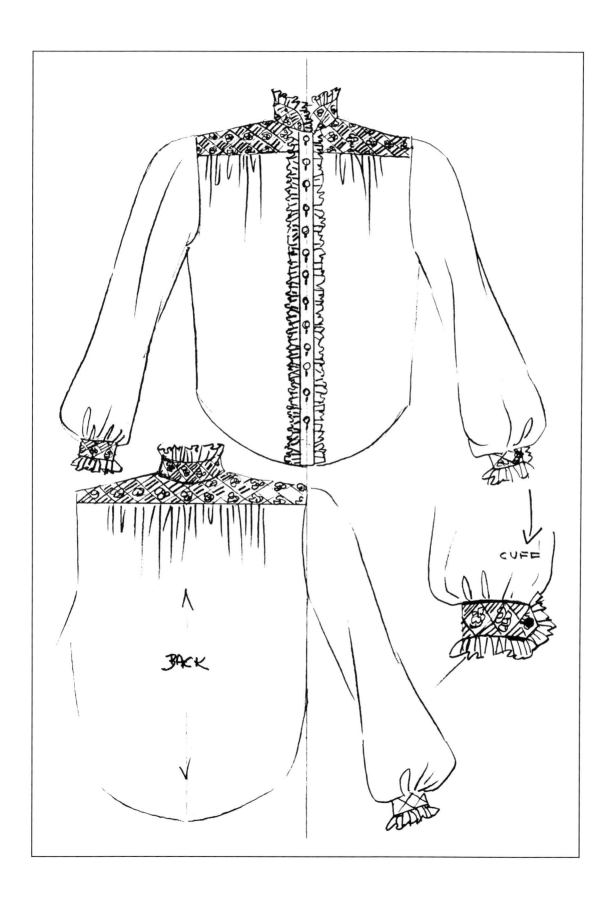

CUFF

BACK

QUICK POSES

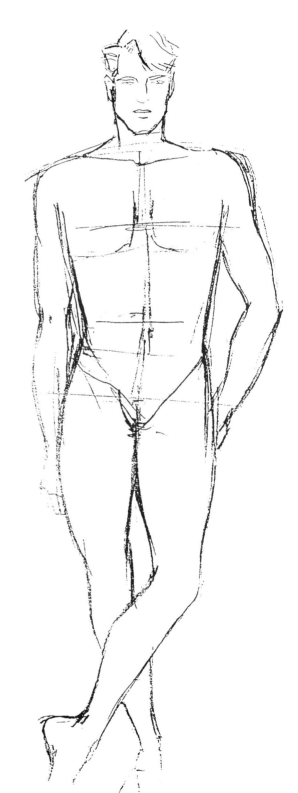

An appearance of supreme confidence in a drawing, whether a design idea or an illustration for publication, always gives the best impression. This boldness can only come with practice, but a very useful exercise is to use a layout pad and only allow a limited time to complete the drawing. It is probably worth drawing the same pose about 20 times before moving on. Under that pressure many attempts may be destined for the waste-paper basket, but one or two might give the nonchalant air of a well-practised expert whose few lines on paper exactly capture the shape, style and essence of the garment. The more this is done, the quicker the throw away rate will decrease. These drawings may not necessarily be of presentational quality, but can be used as shorthand references for a finished drawing. The next few pages contain examples of these quick sketches, some of whose more 'finished' versions will be recognized in the final section.

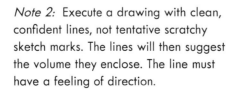

Note 1: To keep the eye in, the artist should also continue to draw from life, either in the studio or in a note book on the bus or train, even sketching in front of a full-length mirror.

Note 2: Execute a drawing with clean, confident lines, not tentative scratchy sketch marks. The lines will then suggest the volume they enclose. The line must have a feeling of direction.

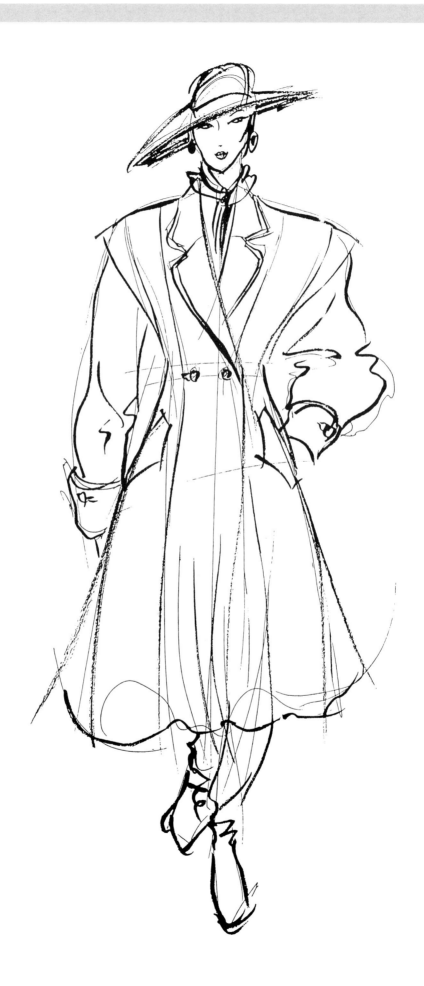

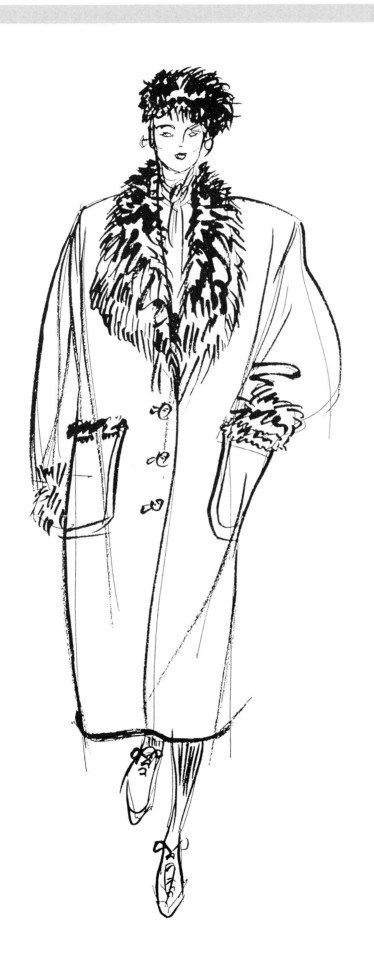

FINISHED DRAWINGS

Finally, the student illustrator should be able to complete finished drawings to presentation or publication level with existing poses and bold indication of style, line, texture and image.

To recap – fashion illustration is a commercial art form with two different but overlapping applications. Either an ability to express an original design idea for the benefit of a design studio for pre-production, or as an advertising or journalistic representation of a completed outfit which should reflect not only the garment shapes but the whole style of the concept.

Artistic influences can be adopted and adapted from anywhere, but however rule-breaking or abstract the finished illustration may be, it should always be remembered that the drawings show humans wearing clothes.

The ability to draw the clothed human form with confidence, from knowledge of its skeletal structure, to the depiction of the smallest garment detail, can be achieved through an understanding of these basic principles of fashion drawing.

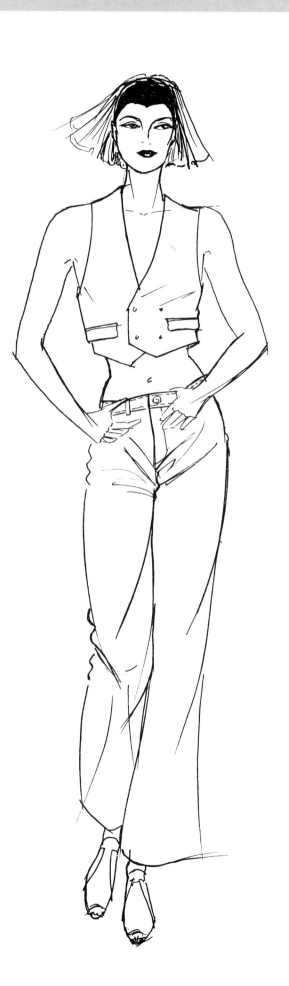

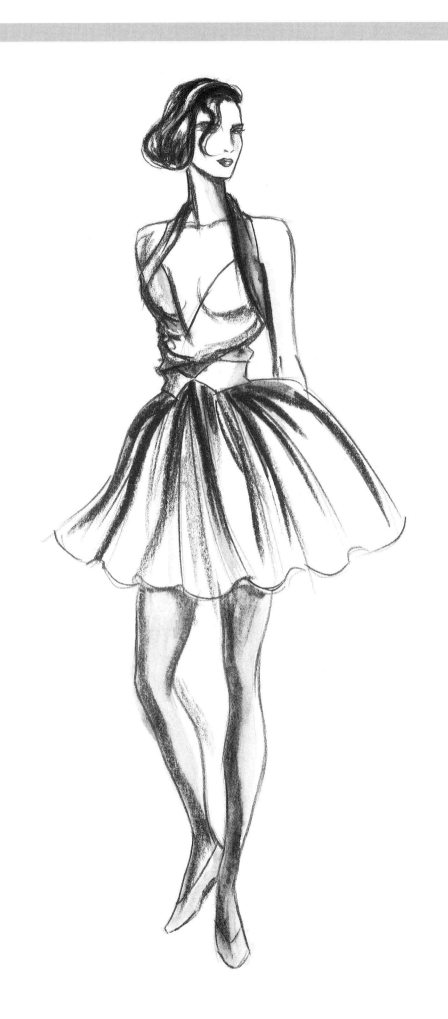

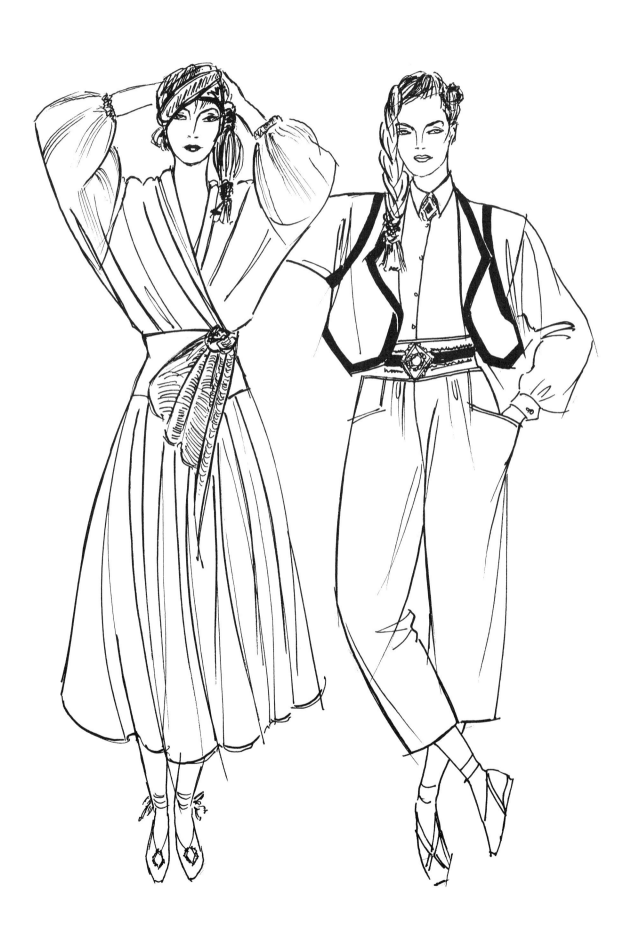

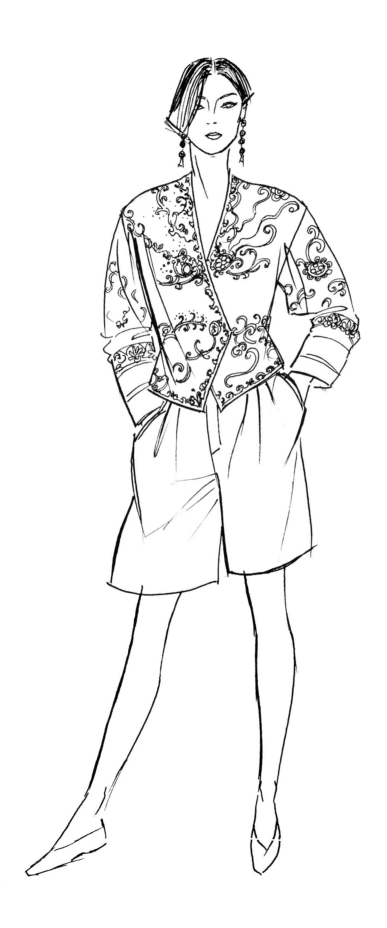

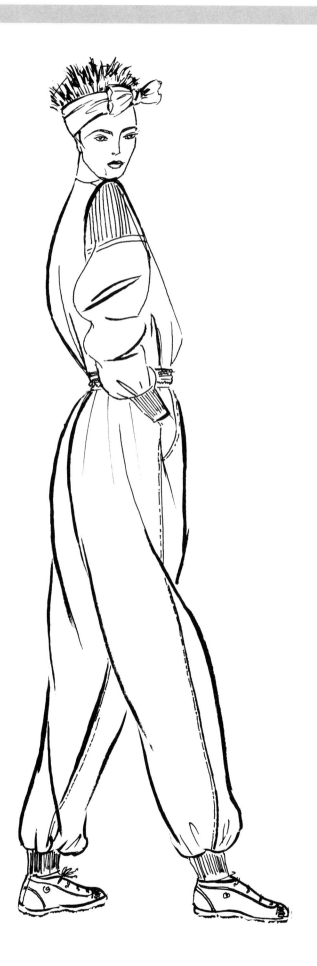

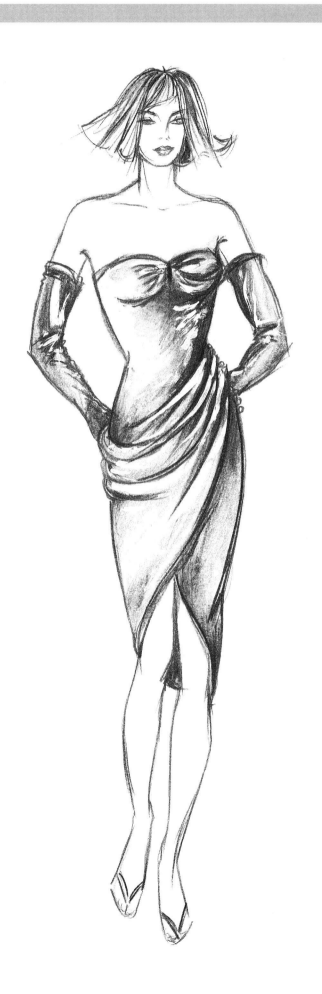

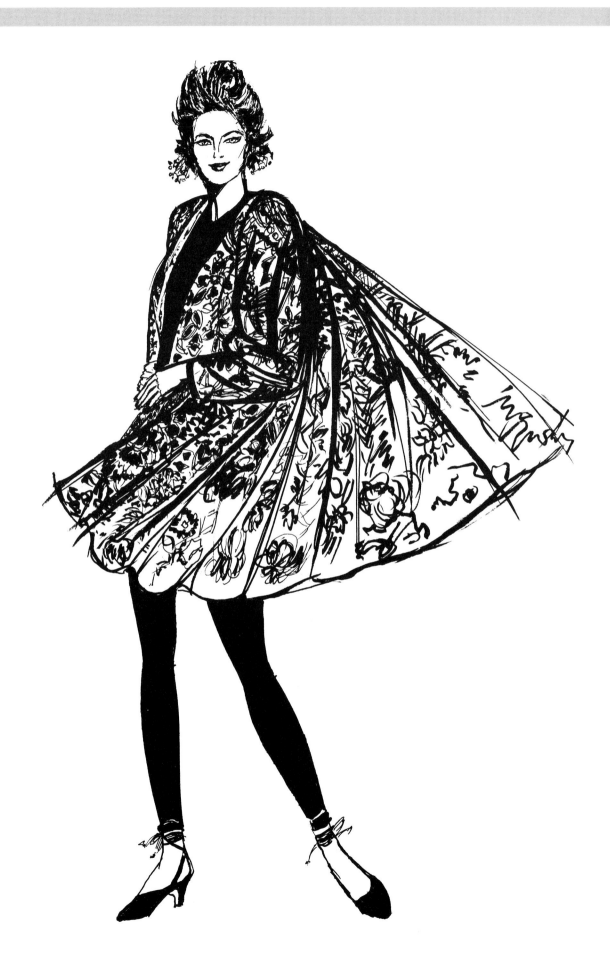

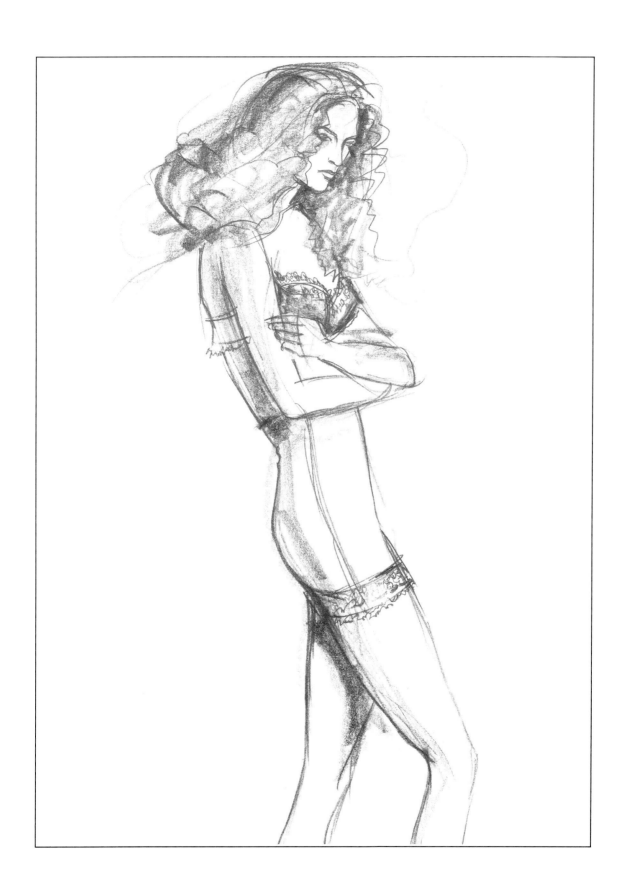

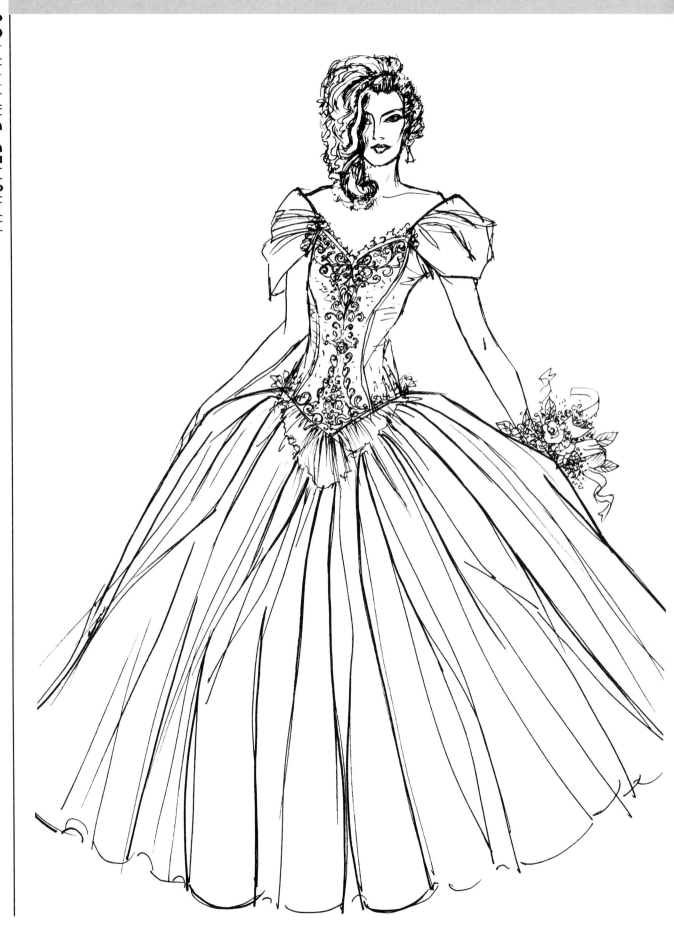

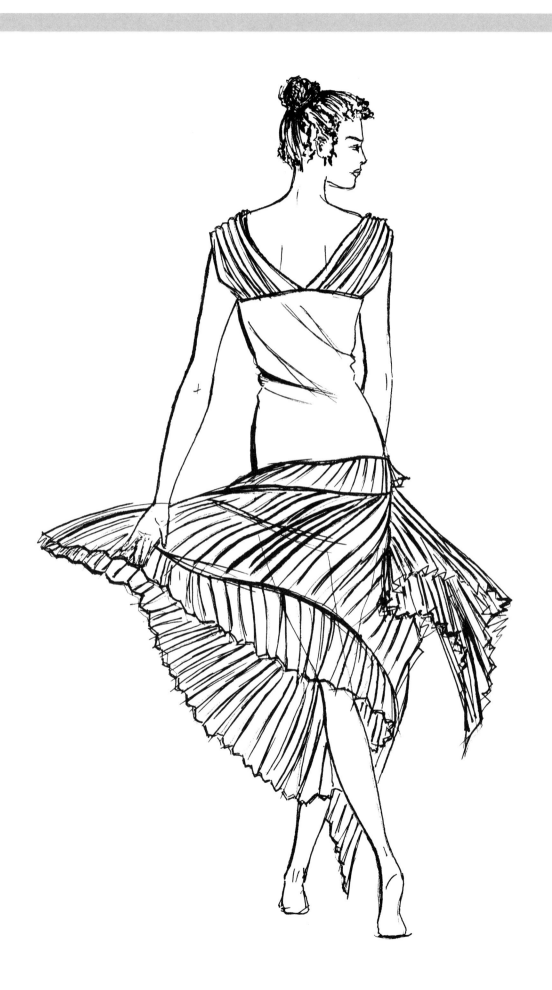

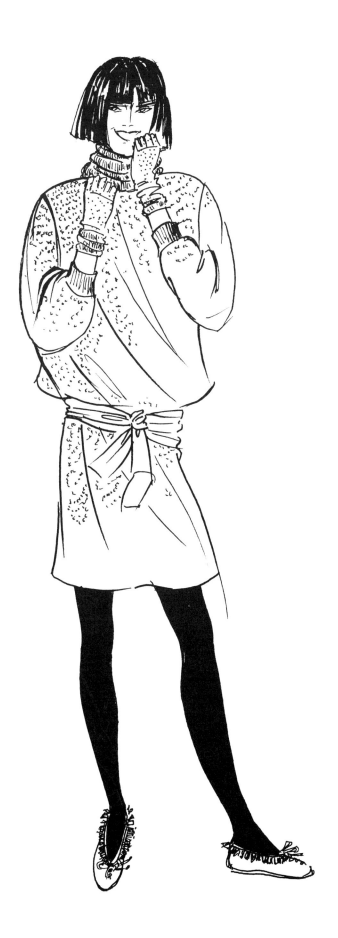

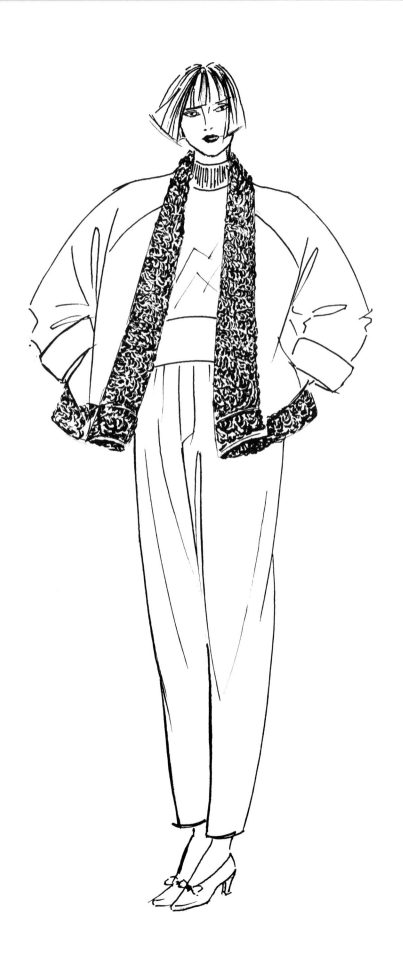

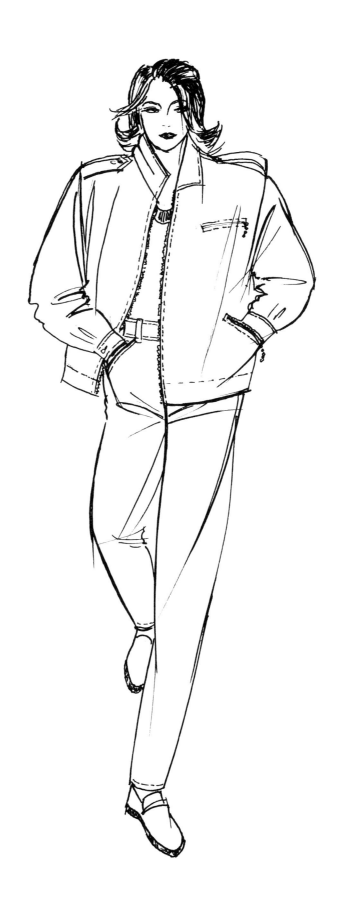

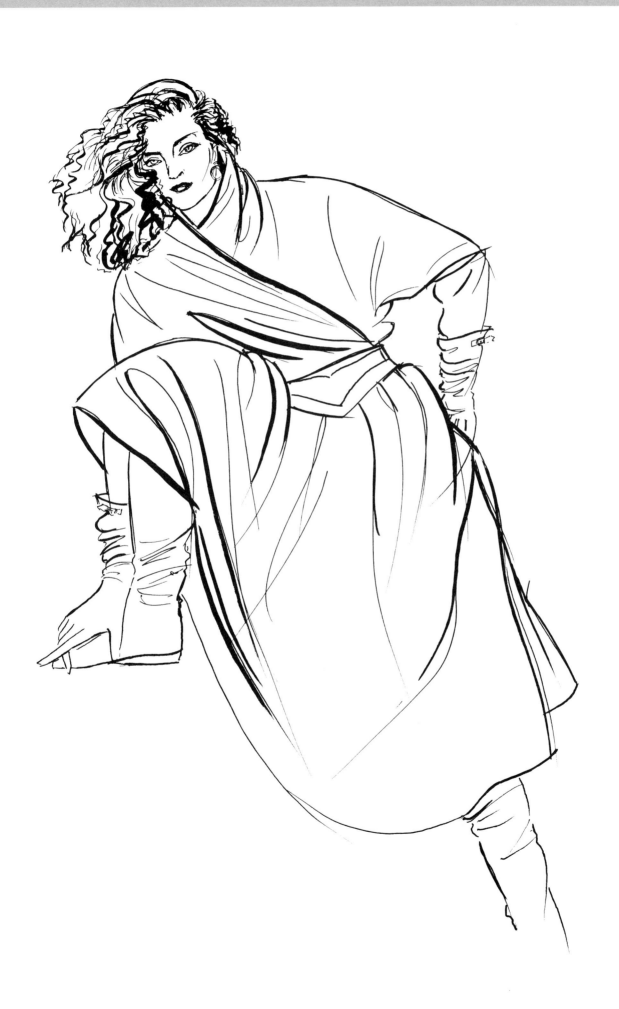

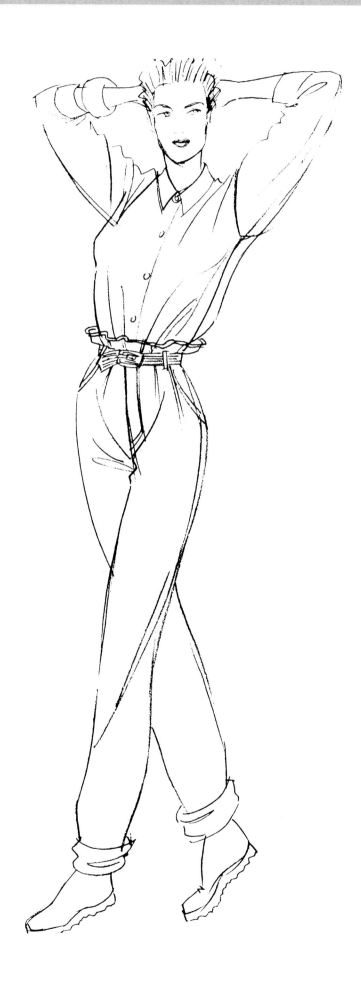

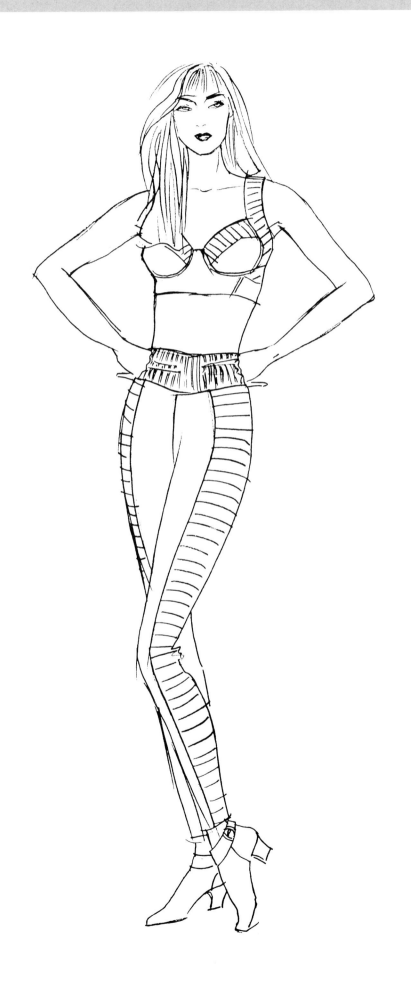

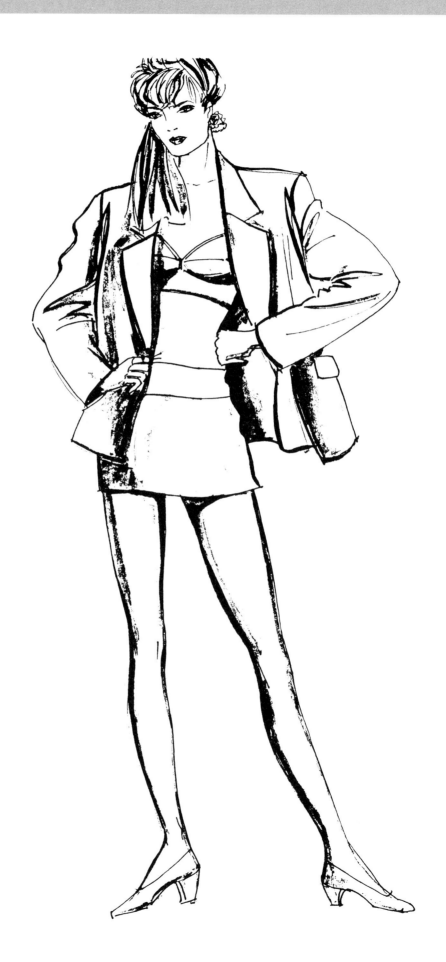

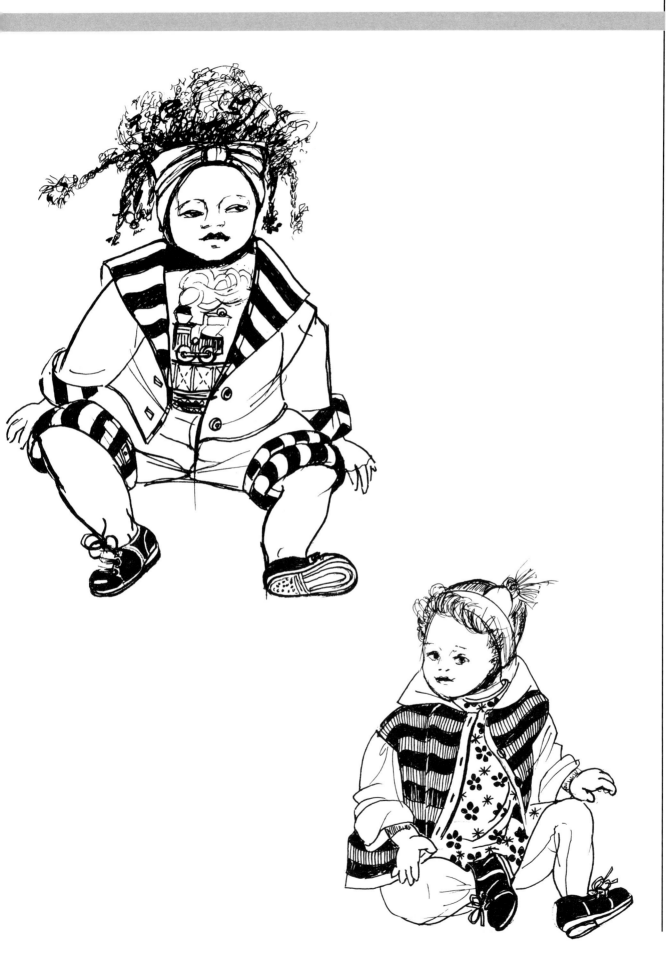

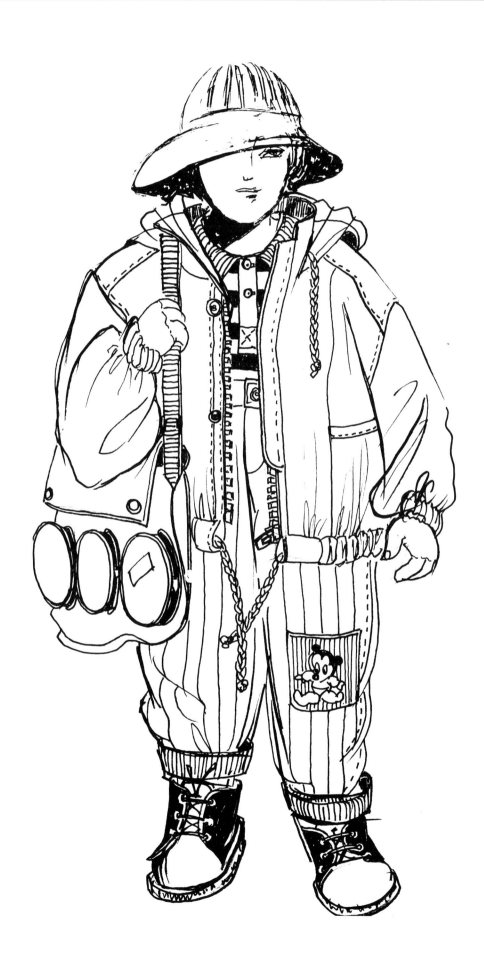

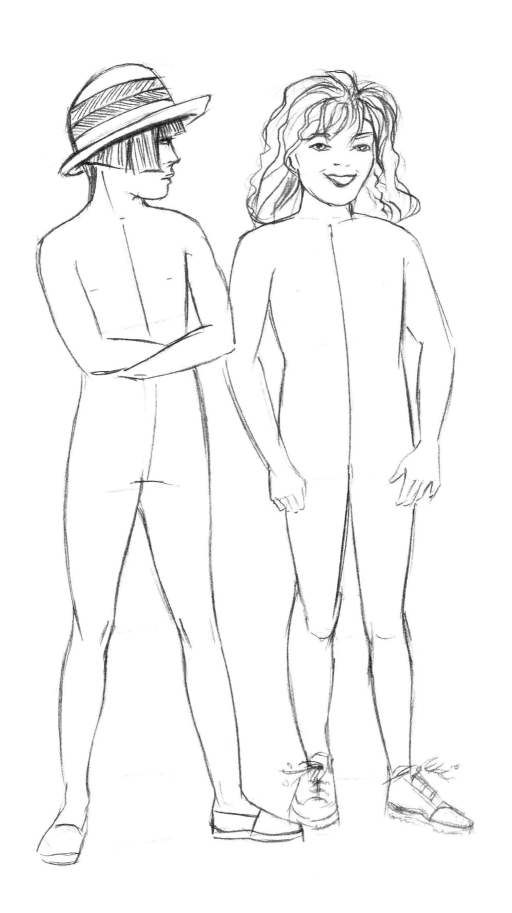

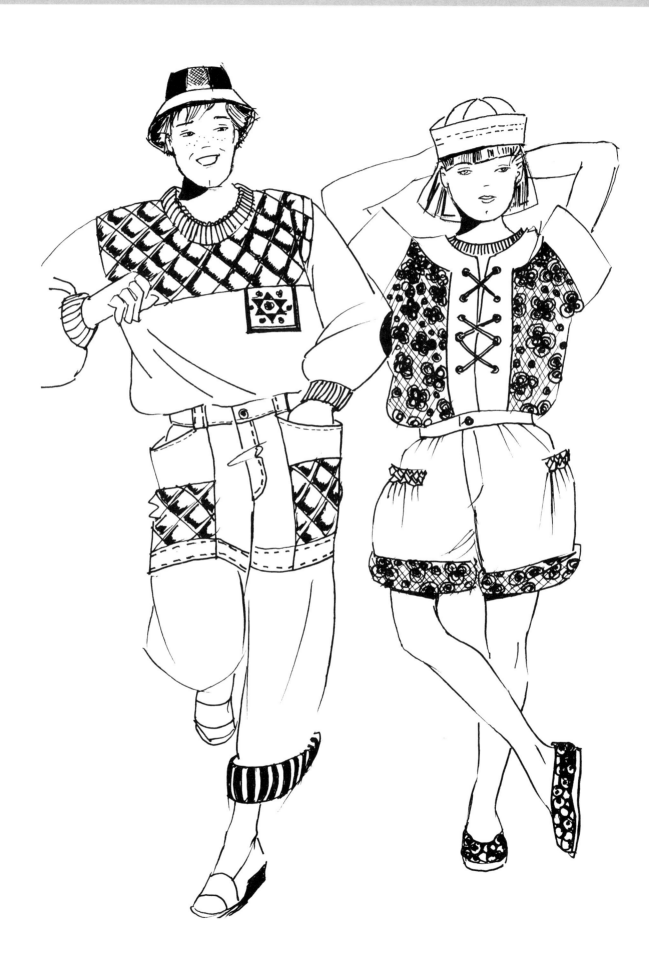

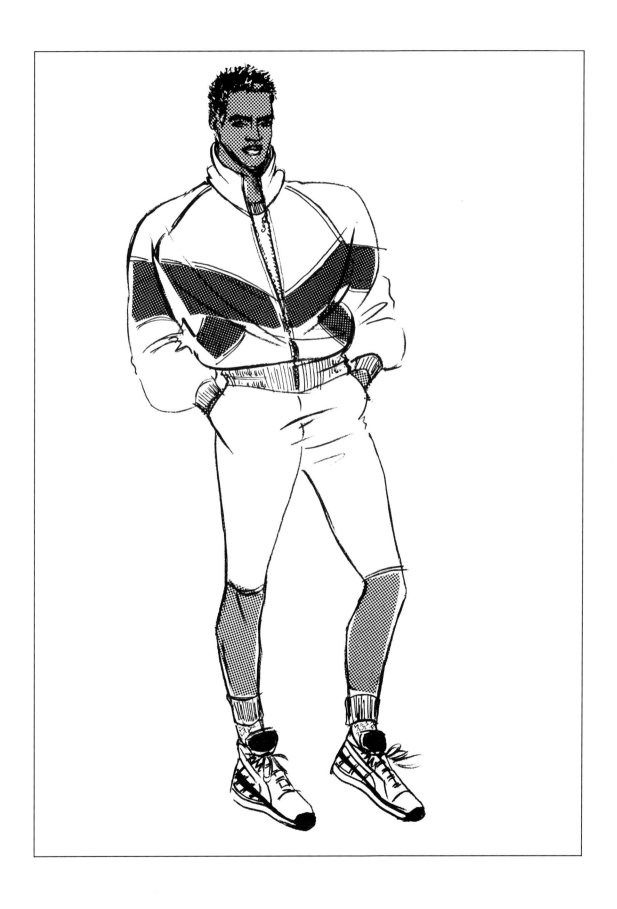

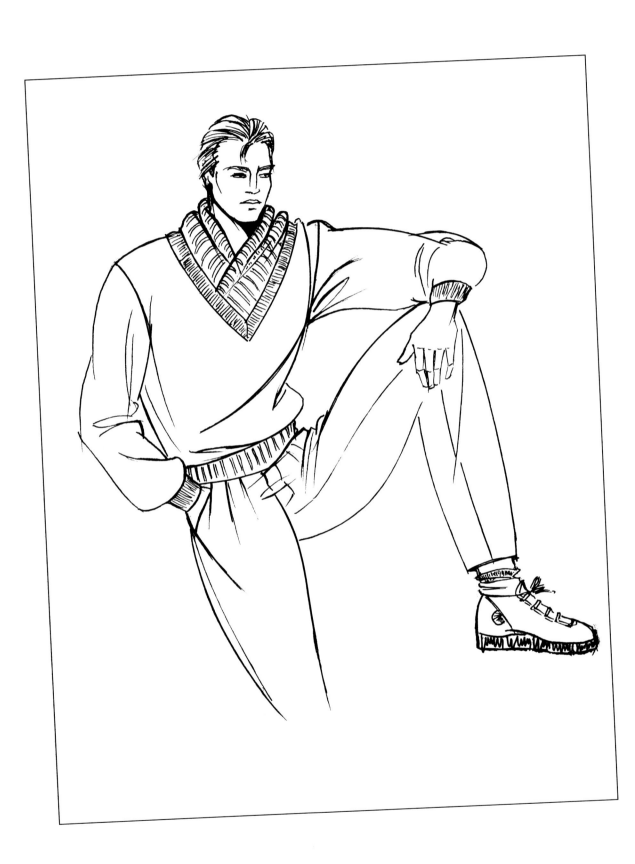

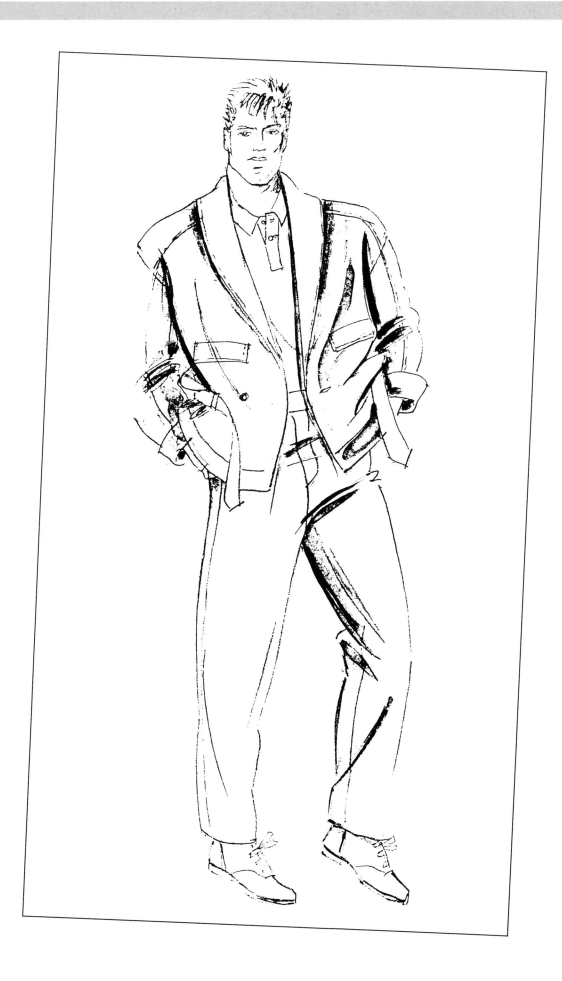

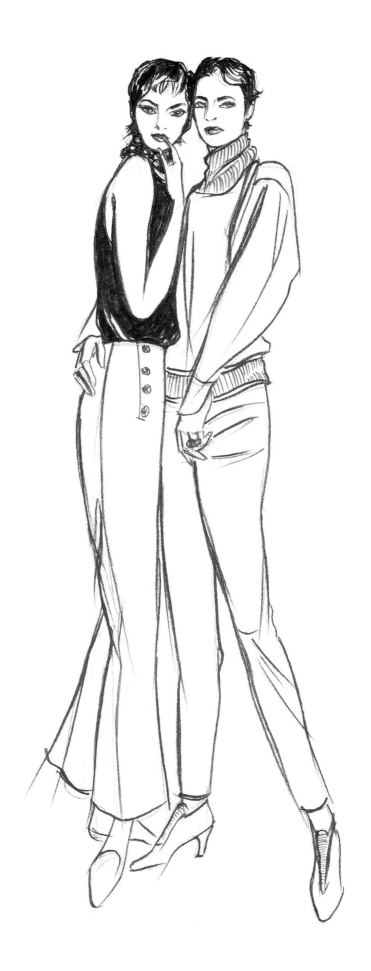

INDEX